Chris
It is rare that I see
a book and instantly
realize you would like
a copy. This was one
such case. Enjoy.

love
dad.
2006

The English Lettering Tradition

from 1700 to the present day

Alan Bartram

Lund Humphries

First edition 1986
Published by
Lund Humphries Publishers Ltd
124 Wigmore Street London W1H 9FE

British Library Cataloguing Publication Data

Bartram, Alan
 The English lettering tradition: from
 1700 to the present day.
 1. Lettering – Great Britain – History
 I. Title
 745.6'1'0941 NK3630.6.G7

ISBN 0 85331 512 4

Designed by Alan Bartram
Made and printed in Great Britain by
Butler & Tanner Ltd, Frome and London

Contents

Author's apology to Scots, the Welsh and the Irish

In this book I use the term *English* vernacular lettering.

Much fine lettering can be found in Scotland, particularly around the Borders, and important contributions to the development of type design were made by Scottish designers. There is good lettering in Wales, too – especially on the chapels. In both countries, the styles are identical to those in England. This book also includes examples from the Republic of Ireland, which after centuries of British domination has a pervasive and lingering English lettering tradition. This is now being developed with Irish imagination, but it is still, today, in my view, of basically English character, carried to extremes. This makes it pertinent to my thesis of the importance of *developing* traditional forms.

So: this book is concerned with lettering in the British Isles. I use the term English as shorthand, and hope that Scots, the Welsh and the Irish will forgive me.

Introduction

O World! O Life! O Time!
On whose last steps I climb.

That quotation from Shelley, beautifully calligraphed in
the English tradition, used to greet you as you approached
the top of a steep and excessively long flight of stairs, like
a set from some German expressionist film, up to the
offices (now removed) of a well-known publisher. That it
was a splendid piece of hand-drawn lettering was, I
always felt, very English.

Why is the standard of lettering in this country often
rather high? Why, despite being deflected, firstly by the
art nouveau movement, and secondly by a love affair with
Trajan Roman in the first four decades of this century,
are we today perhaps the only Western people to have a
national tradition of fine letterforms in vernacular use? A
penchant for linear forms is not a sufficient explanation;
and I do not know the answer. The purpose of this book
is simpler: to worry out the characteristics which con-
tribute to the distinction of our lettering, and to show
how the various basic native styles of letterforms can be
given countless personal interpretations whilst retaining
their basic integrity.

This book is about vernacular lettering, a term not easy
to define precisely. I think we might best begin by listing
the groups of lettering which, although sometimes alluded
to, have not been properly covered in this book, because
they seem to me outside the vernacular tradition.

Firstly, I have shown no printing types. Apart from the
work of some of the later West Country tombstone
carvers, the vernacular tradition has been little influenced
by type designs. Indeed, the influence has often been very
much the other way round. Even today, signwriters are
more likely to use their own designs, developed from
traditional models, than copy type styles – a dreadful
practice, much favoured by the large commercial sign
manufacturers, who know no better.

Secondly, I exclude the work of the writing masters. I
am on dodgier ground here, for some of their work was
closely imitated by certain tombstone carvers, as we shall
see. But although they helped form the English lettering
tradition, they were not of it; professionals, not tradesmen,
they were rather keen on their personal status in the
fashionable world.

Thirdly, I exclude the lettering of the craftsmen working
broadly within the Arts & Crafts movement. For the first
sixty years or so of this century, this group had its own
slightly rarified tradition, preferring to look back to his-
torical forms (including some of the tombstones shown in
this book) in a mood of emulation rather than inspiration.
Far more inhibited than the vernacular tradesman, such a
letterer, in this country, seemed to exist in a cosy back-
water, rather than operate in the mainstream. Discreet
good taste was all; which never got the English lettering
tradition where it was in the nineteenth century, or even
the eighteenth.

Happily, the last decade or so has seen major changes
in the thinking of this group of craftsmen, as they apply
their skills both in more creative ways, and in ways that
meet the needs of today. But this work, often conceived
as an art form by the craftsman, or 'artist craftsman' as
many prefer to call themselves, is clearly on a different
level, and is to be approached with a far more ruthless set
of critical values, than the workaday pieces that are the
subject of this book.

Fourthly, I exclude the work of graphic designers. This
is a young profession, scarcely existing before the mid
twentieth century, and has a very different background
from the vernacular trade. And the differences may help
to clarify the factors governing my choice of material.

The trade letterer works within a tradition handed
down from master to apprentice, or from father to son;
the designer has usually studied in a design school. The
tradesman will execute the final lettering himself, but the
designer usually provides working drawings of some kind
to be interpreted by another craftsman. The tradesman
derives his designs from the tradition in which he has been
taught, forms which have already been used in similar
situations, although he may contribute personal man-
nerisms; the designer is concerned with solving an often
self-inflicted intellectual problem, with creating a personal
and possibly original interpretation, and is liable to draw
inspiration from a wide variety of sources – often from
areas quite outside that for which he is designing. Vari-
ations within the vernacular tradition are often the result
not only of conscious modification, but also of ineptitude.
This can create its own charm. A designer's ineptitude
usually simply looks inept. (It is a mysterious business.)

The designer's approach may result in some kind of pastiche, or semi-pastiche, but the trade letterer's creations are almost never this. If a tradition is alive, it is axiomatic that past examples of the tradition are not merely copied, but developed. Thus lettering created today by tradesmen working in the vernacular tradition is rarely exactly like the classic examples created in the Victorian era. But designers might recreate them almost exactly. A good example is the redecoration of many pubs in the early 1980s, which resembled a kind of living museum of Victorian lettering (the result perhaps of some campaign for real lettering, companion to the campaign for real ale). This 'non-house' style was created by professional, sophisticated designers, whose close following of vigorous nineteenth-century originals was legitimate. Unfortunately, their work has now been partly replaced by the effete letterforms of an ill-conceived house style: a distinctly retrograde step. But both approaches are the work of a professional team of designers and, as such, are outside the scope of this book.

A group of lettering which might also be thought to be outside the scope of this book, but which I *have* included, is railway lettering. It seems to me the apotheosis of Victorian vernacular; and is so closely related, in all its guises, to the rest of the work I show, that its exclusion would be perverse. It can be seen as the thread that binds the second half of the book together, as tombstones bind the first.

So: this book sets out to examine the richness, variety, quality and pervasiveness of vernacular lettering in the British Isles from about 1700 to the present day. It is not primarily a history: it seeks to show how the same styles were used, higgledy-piggledy, in different situations and, suitably adapted, in different materials; how 'vernacular' craftsmen were sometimes influenced by 'professionals' such as writing masters, type designers, possibly even architects; and how the tradition continues despite outside influences which have to some extent undoubtedly injured it, and could destroy it. If this book delays or, better, helps to prevent such destruction, it will have achieved its primary purpose.

It also shows how the English vernacular tradition owes almost nothing to the classic Roman letter – or indeed any Roman letter – despite the reverence with which this letter (the Trajan form in particular) was held at the beginning of this century. The existence of a cast (since shown to be slightly distorted) in the Victoria & Albert Museum, was the haphazard cause of this reverence, which resulted in the blanket application of Ministry of Works (later Department of the Environment) Trajan on all official signs. This style became increasingly inert until, recently, it began to give way in many instances to capitals and minuscules painted in forms far more within the English vernacular tradition. And although the Festival of Britain of 1951 is often derided, I think it was probably the deliberate use there of lettering which was 'British in feeling', consciously reviving nineteenth-century forms, that stemmed and then eventually reversed the tide of Trajan that threatened to overwhelm the native tradition.

The first of the English forms was initiated long before a general awareness of Roman models; and while its remote ancestry has to include aspects of Italian Renaissance ideals, there is no conscious or direct influence from these either, only a background of an impossible-to-ignore chain of type-design development from Manutius to Caslon. English forms grew out of particular English preferences which can be seen even in many early primitive forms; and it seems that, left to themselves, the British tend to revert to these preferences even today.

Generalising crudely, one might say that Germanic forms of seriffed lettering with strokes of varied weight, and even some grotesques, tend to be somewhat angular, with a calligraphic feel – perhaps a vestigial trace of black letter forms still in use up to the 1940s. German lettering has indeed a strong character of its own; but I'm not sure that it can be called a vernacular. Georg Trump's Schadow and Hermann Zapf's Melior are good examples from the type world. Such vernacular style as exists seems to be based upon broad-nib letterforms; examples can most readily be seen in wine-producing areas (presumably in order to suggest old traditional qualities) and, to a lesser extent, in mountain (holiday) regions.

The characteristic French form, unlike the German, seems to have a marked, even violent, contrast of thick strokes and thin, the latter often of hairline weight. The transitions from thick to thin are abrupt. One thinks of Fournier's or Didot's types (the latter were the first true

'modern' type faces) and, on a bolder scale, enamelled street-name plates.

Italian vernacular forms seem to have no particular family characteristics, though debased Roman or Renaissance forms are quite common. Spain has a good tradition of decorative, often mannered, lettering, almost fierce in effect with, later, a strong art nouveau influence.

All these countries, and others, have fine and inventive lettering, but, I believe, no national vernacular tradition as we know it.

The English form of seriffed, varied-weight (stressed) letter, the norm to which the vernacular form gravitates unless there is good reason for it to resist, has a rich full shape, a vertical stress, and fairly sharp gradation from thick to thin strokes; although it is less abrupt than in the characteristic French form. The difference of weight between strokes thick and thin is often quite marked; the

latter are often virtually hairlines. Rich bracketted serifs terminate sharply, if not always actually to a point. The tails of the Q and R usually have great verve, the tail of the latter being bowed, not straight. Proportions tend to be squarer and more regular than those of Roman forms.

This style seems to me so English, so characteristic, that I have elsewhere called it 'english', and shall continue to do so here. Brought within its definition are many typefaces with 'Modern' in their title, such as Modern No. 20. For me, the true 'moderns', if we must use that silly name, are the Didots and the Bodonis, with their ungradated changes from thick strokes to thin.

A variant of the english letter, the script, eventually developed in several directions. Naturally evolved from quickly-drawn minuscule english letters, scripts also have an ancestry all their own: the models shown by the writing masters in their pattern books. Some might say the english letter and scripts share this common ancestry. Abroad,

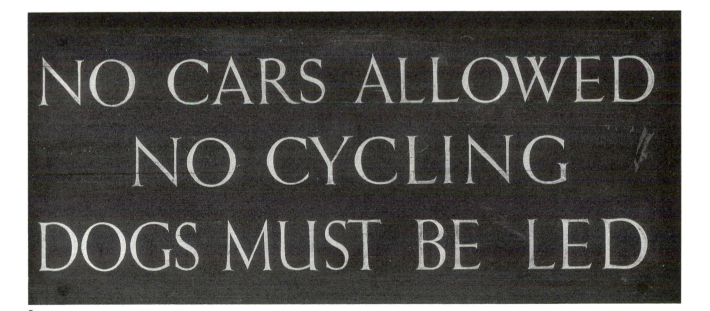

1

A sign in Richmond Park, Surrey, shows the Ministry of Works Trajan (1) nearing the end of the line, although still well painted and fairly close to the original. But the need to replace this terminally-ill design became urgent.

such forms are often known as 'English script', although 'copperplate' (equally revealing) is perhaps the more generally recognised term in this country, derived from the copperplate engravings of the writing masters. They have been shown capable of more personal, not to say bizarre, development, than any other basic form.

Such are the roots of our tradition; but its strength lies in its variety. The style generally known as clarendon is to all intents and purposes a bold english letter, although its general effect can look surprisingly different. The thins are naturally never hairlines; the serifs never pointed, but square-cut or rounded, although always bracketted; a form known as 'latin' has triangular serifs.

The grotesque is a form without serifs and usually, but not necessarily, of fairly even weight, although this can vary from hairline lightness to a boldness so extreme that the centres or counters of the letters virtually disappear.

The egyptian is in effect a grotesque with slab, or rectangular, serifs, and is as capable of accepting extreme variations of weight and form. Oddly, in appearance it is often closer to a clarendon.

Such stylistic groupings, which can be subdivided well beyond the limits of patience or even sanity, are merely pigeon-holes for historians or typographers.

There is a final quite uncontrollable group of decorative forms, which can be developed on the basic forms described above, or be florid styles with a charm or something all their very own, where the form *is* the decoration: typical manifestations of mid- to late-Victorian taste.

Although there may have been freak isolated appearances elsewhere before, the first serious and widespread use of all these styles (except the *idea* of decorative letters) occurred in Britain. In this country too, all, including the decorative forms, had a richness and assurance not seen elsewhere except in America, which imported this tradition and developed it with skill and invention. This is not to say that splendid examples of these forms cannot be found in Europe; but they are not around as a matter of course. Grotesques are abundant, but they rarely have that special rich English flavour that, to my eyes, is present in all the basic styles. Only the decoratives flourish to the same degree as in England; and here national differences are quite distinctive.

The english letter made its official appearance in 1754 when the printer, lettercutter, writing master and japanner John Baskerville began producing his innovative letterforms; although there can be no doubt that his designs were based on styles which had been developed by tombstone carvers twenty or thirty years previously. The clarendons, egyptians and grotesques emerged from the dense smoke of the Industrial Revolution round about 1800. But long before the first definitive forms appeared, many characteristics which now seem particularly English could be found in the primitive letterforms of early tombstones, builders' marks and dates on houses, and even in Caslon's types, derived though they were from Dutch models.

Other countries can show lettering stretching back centuries; but, apart from books and manuscripts, it is usually on or in cathedrals, churches, palaces, or monuments – not, as in Britain, on humble houses and cottages, or simple tombstones in country churchyards. Moreover, the foreign examples all seem to derive from quite another tradition: formal and informal Roman, or early Christian, or the 'approved' lettering of the monasteries: half-uncials and Carolingian forms. Admittedly many of these examples are earlier than surviving English vernacular lettering, but this shows no such influence at all. Perhaps this is all the odder since the Carolingian script was derived under the supervision of Alcuin of York, largely from Anglo-Irish half-uncials.

Put bluntly, the early English vernacular letterers of the seventeenth century appeared to be trying to invent lettering all over again, using moreover the crudest possible concept of letterforms, as if unaware (as they probably were) that some of the most beautiful and subtle lettering ever created had been done, centuries earlier, in these islands. Certainly there was no reference back, ever, to Roman forms of any kind; no reflection of early Christian forms or the development of these found on Romanesque churches in Italy and elsewhere; nor, really, of Renaissance forms. What is particularly odd is that, from such crude beginnings, the English vernacular developed forms that became the equal of, in fact became, the 'approved' letterform or groups of forms. English vernacular lettering became, simply, English lettering. To really appreciate this, one has only to think of the two quite unrelated

modes of American lettering today: the hamburger or Mickey Mouse influence; and the superb achievements of type designers and calligraphers. Britain today also has a lot of terrible lettering, but most of it is in the same overall style as the good, just badly done.

It would be wrong to imply that the vernacular actually created the forms eventually used in monuments, buildings, printing, coins, medals, and so on: there appears to have been a continuous and complicated, not to say confusing, exchanging and intermingling of ideas. I suspect there is no pattern of development of lettering in most countries, only of type design. In the British Isles, the history of lettering has to include anything on which lettering can be put – and the British seem to be very ingenious in finding things on which lettering can be put.

The development of lettering is continuous and the result of many factors, and it is unlikely that any new style can be claimed to be the innovation of one individual. John Baskerville came as near as anyone to creating a new form single-handed, but his types were still the culmination of a trend, which he was able to bring to a climax because he had knowledge and skills which enabled him to print the new type forms correctly, on smoother paper and with better inks.

The models of the writing masters published in the last quarter of the seventeenth century and the first half of the eighteenth century were a major influence in establishing a common form of letter style, and created a society which recognised the letterform it had been wanting, when it eventually arrived. Well before Baskerville had cut his first types, tombstones were being carved which were influenced by the copper-engraved plates of the writing masters' books. The somewhat similar methods of engraving in copper and cutting in slate must have encouraged this 'borrowing'. Although how upright minuscules – which form the major part of tombstone inscriptions – derived from specimens consisting mainly of scripts, is not at all clear.

The general brilliance of Baskerville's types was influenced by the copybook designs: he himself was a writing master. Their actual forms however relate far more closely to those found on tombstones. With generous curves, strongly differentiated thicks and thins, long untapered but bracketted serifs, his types were followed in 1769 by what is known today as Fry's Baskerville, with slightly flatter curves (especially in the lower case), and sharper and more generously bracketted serifs. This, to my mind, is the archetypal english letter. These general charac-

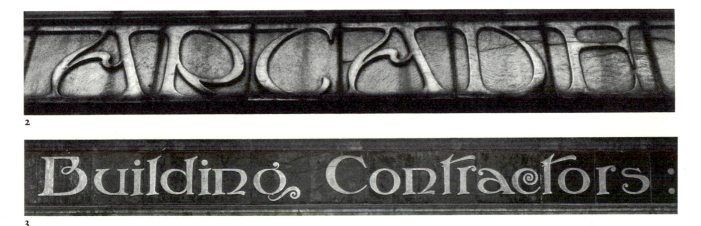

2

3

Two pictures illustrate the second style alien to the English vernacular: art nouveau lettering. Both are in the form of ceramic tiles. (2) is from Norwich, (3) from Hertford. The full-blooded Norwich example shows the style's perverse and neurotic distortions to perfection – if that is the word. The Hertford example illustrates how the style influenced the design of lettering not in itself whole-heartedly art nouveau.

12

teristics have been the basis of the most widespread form of English vernacular letter ever since.

The growth of the sign*writer* (that is, a lettering man) as opposed to sign painter, began in the late eighteenth century. The obvious models for the lettering were writing masters' copybooks and printers' type specimens. These were necessarily on a smaller scale than required, so books soon appeared for signwriters and lettercutters, using the smaller-scale models but incorporating the modifications which were (and *are*) essential for the larger scale. Right from the beginning, types were only a *basis* for signwritten forms; these must have rapidly developed in their own way, reflecting the quite different manner of execution. Painted, carved or cast letters each require their own discipline, quite apart from modifications arising from the personal whims of the executant, or even from his lack of the necessary skill.

By the early nineteenth century, commerce and industry required more aggressive letterforms. At the same time architects, aided by the intelligentsia, developed theories about primitive and elemental simplicity, such as (they believed) the currently fashionable Greek idiom displayed. Thus was developed the idea of a simple, more rational (and therefore more 'Greek') form: what we now call the grotesque, that is, a letterform, often monoline in colour, with no serifs. Egyptians, as has been said earlier, are grotesques with serifs. That such letterforms are more suitable for architecture is indisputable. But, besides being more architectural, they could take on forms which were far more aggressive than the civilised and refined english letter. So a letterform dreamt up to solve an intellectual and archaeological postulation was seized upon by signwriters and, soon, printers, to perform deeds quite beyond, in fact almost contradictory, to its civilised progenitors' ideas.

Letters without serifs have always existed, but they were usually the work of naive and unskilled carvers (or painters). James Mosley has pointed out what may be the first sophisticated sans-serif since the quite different forms of the early Renaissance. It is to be found at Stourhead, Wiltshire, in the grotto of a garden designed to recreate the world of Virgil in the English landscape. Its date is about 1750. The inscription is in capitals and minuscules, with stressed forms. It appeared to have no progeny.

The classical revival was soon reflected in the work of architects. By 1789 Sir John Soane was using a carefully drawn sans-serif letter in his drawings, both as titling and also on occasion as an inscription on the building itself. About the same time, sans-serif lettering began to appear on sculptural monuments. By 1806, rude remarks were being made about the current shop boards displaying 'common characters deprived of all beauty and all proportion by having all the strokes of equal thickness'. The grotesque (and, probably a little later, the egyptian) had arrived in town. The first sans-serif type was produced by William Caslon IV in 1816; the first slab serif type was shown by Figgins in 1815, in capitals only, although by 1821, at the latest, lower-case letters were available. No lower-case sans-serif letters were generally available in type in England – except Thorowgood's 1835 grotesque, a bold condensed letter which had little success – until the 1870s, although in America and Germany they were in use long before then. In the non-printing vernacular tradition, very little use was made of lower-case (or minuscule) letters in any style, except on tombstones – particularly those cut in the english letter – and (obviously) work done in scripts.

After the 1820s, designs flooded out. Both typeforms and vernacular letters assumed wilder and more varied guises (not to say disguises), exactly as today, and for the same reasons, that filmsetters and transfer lettering manufacturers are bringing out so many new forms. Then as now, along with much rubbish, some superb forms were developed, in a desperate effort to surpass their rivals. Many signwriters attempted to develop some personal characteristics, as they do today; and one has only to look at photographs of Victorian cities, towns, and villages, to see how much lettering was produced. The market was huge, but the competition was probably fierce.

Today, the job of signwriting is often combined with painting and decorating, either by the same craftsman or at least within the same firm. It has probably always been so. The work is often done at what seems to the layman to be breathtaking speed, in many cases with a mere skeleton of the letterforms first sketched in between two horizontal guide lines. Some craftsmen however work out the design on paper, then pounce through pin-holes following the design, or transfer it down.

Many of the early stones show two scored horizontal guide lines and this, together with the odd word breaks, changes of size, unusual abbreviations, and letters poked in strange places, suggest that the cutting was pretty direct. The results gain vigour and charm even if they lack refinement. Later designs are generally too formal and too carefully worked out for such direct cutting to have been common.

While the earliest tombstone makers were masons undertaking any form of building work, the job later became more specialised. Often the skills were handed down from father to son for several generations, and they frequently signed their work (so, for that matter, do many signwriters today sign their fascias). These later carvers knew exactly what they were up to. They were professionals, and as such should not, strictly, appear in this book about vernacular lettering. They were aware of the latest copybook styles, interpreting them into their own medium. The most professional of all, around Grantham and the Vale of Belvoir, were far more than lettercutters, for their ambitious designs often included many fashionable decorative motifs, culled from books for cabinet makers, and even architectural motifs from for instance the Adam brothers' books of 1773 onwards. Other tombstone carvers used similar sources. The mid nineteenth-century Cornish carvers clearly had a good supply of type specimens to hand, which they skilfully exploited, but they were not in the same class as the South Midland men.

It has been suggested, and the style of the majority of stones supports this, that most tombstone carvers were considerably less sophisticated than the great men working around Grantham and Melton Mowbray. Many probably frequently turned their hand to other types of work, including general signwriting. Some are known to have been, primarily, schoolmasters or parish clerks. This unspecialised working life could well have resulted in a more open-minded acceptance of outside influences on forms and working methods.

However, the idea that vernacular lettering must necessarily be homely or clumsy, and that the practitioners of it are also this, is contradicted when one looks at the actual lettering. Some early tombstones can be described, but not dismissed, as having rural charm; some painted fascias may also have certain awkwardnesses; but so much

work, even today, is as good, or very nearly as good, as the most skilful type design. Nor can the techniques be called elementary. Signs may be executed in carved wood, gilded, and covered with glass; individual letters might be constructed out of carved wood, as subtle as sculpture, and gilded; or cut, etched or sand-blasted into glass, and perhaps painted and gilded; letters may be of ceramic, or terra-cotta, or metal (cast, engraved, or etched). These ambitious forms are all normally considered as being in the vernacular tradition.

The most pertinent dictionary definition I have seen explains vernacular as the 'native speech or dialect of a people, as opposed to literary language'. From that starting point we can consider printing, which ranges from old trade bills and such-like ephemera clearly in the vernacular, to the most distinguished, non-vernacular, book printing. Printing speaks both the 'native speech' and the 'literary language' of a people. Type designs would normally be considered to be among the aristocracy in the hierarchy of letterforms. Many pieces of vernacular printing use the same types in which books are printed. Many books are thrown together looking like the dog's dinner, inept; while some simple ephemeral business card may have been designed, for a large sum of money, by a designer, in a very sophisticated manner. Can the same type design be speaking in the vernacular one moment, and in literary language the next? The answer seems, confusingly, to be yes.

Writing masters, a trade or profession which no longer exists, are not, I think, to be classed as practising the vernacular. Why then have I included the tombstone carvers, who frequently create designs every bit as skilful as those of the writing masters? Could it be merely that it is a slightly dirtier job? – all those stone chippings, and dust everywhere. But without their work, my story almost disintegrates. I am beginning, as you see, to get very entangled in an attempt to sort out vernacular from, well, non-vernacular.

Many of the stock letters used on shopfronts are lines produced, not by a specialist lettering firm, but by a large manufacturer of quite other objects in the same material: ceramics, cast iron, tiles. Purportedly vernacular lettering was (and is) cast by large foundries making anything from street bollards to mining equipment. Lettering on these

manufactures is the result of pressing pattern letters into the sand forming the mould. For this purpose, standard brass letters, originally almost always a clarendon, although pedestrian grotesques became common later, were provided by outside specialist firms. Whatever the style, the end result necessitated a lengthy chain of industrial processes.

In contrast, any form of letter printed from engravings was the personal creation of a highly skilled engraver, even though he may have been following a traditional form. As lettering on silverware, or on maps, as titles to illustrations, as printed devices and labels, or as designs to be transferred to ceramics, the characteristic form, with its contrast of hair-line thins gradating into quite bold thick strokes, and long, bracketted serifs – classic english form – was capable of many individual interpretations.

Such lettering was closely akin to printing types. But other forms of pottery had lettering drawn (or even modelled) directly onto the unfired object, and was thus the result of a more intimate relationship between craftsman and end product.

Is lettering on architecture in a literary language? Most architects know nothing about lettering, and why should they? In many cases they employ lettercarvers or designers, as Basil Spence employed Ralph Beyer in Coventry Cathedral, and Richard Sheppard employed Edward Wright in Churchill College, Cambridge. As previously mentioned, Soane appeared to be fairly competent at drawing lettering himself, although it would have required adjustments by a professional lettercutter if it had been actually put up on the buildings. Either way, architect or outside designer, the lettering is professionally designed.

Monuments and monumental sculpture? A lot of the lettering on these is rather poor. Often it was done by the sculptor, sometimes a professional lettercutter was employed, sometimes ready-made standard polished brass letters were supplied by a specialist firm, as with the cast letters mentioned above. After about 1820, the status of lettercutter changed from a casual mason to the employee of a more highly organised business. This seemed to lead to greater technical skill but also to less inventive letter-

A pub fascia in Fulham Broadway, London (4) is a designer's design. It shows all the characteristics of the English vernacular tradition: vigorous, rich, strongly contrasted forms with carefully painted shadow and reflection effects on the returns, and cast shadows playing an important part in the design. (That, in this photograph, these appear lighter than the background is a trick of the lighting conditions at the time; although such a pleasing if irrational notion is not beyond the whims of a signwriter.) The very generous serifs are especially typical of the trend today in the vernacular itself.

If vernacular letterers want a model, here it is.

forms, and soon no life was left in the tradition at all.

Coins and medals must surely be in the 'official' language. Lettering on these was cut as individual letters on steel punches, just like type. These were punched into the die to form the inscription; the coin was struck from the die. In the late seventeenth and early eighteenth centuries, and again in the nineteenth century, the standard of lettering – quickly developing into english letters or clarendons – was often high. At the end of the nineteenth century, the designer (by now usually a sculptor) was able by means of the pantographic engraving machine to design his own lettering, often with dire results. The engraved lettering on bank notes, likewise, becomes more inert with every new issue: neither a reflection of the engraving technique, nor good forms in themselves.

Are signs in Royal Parks in 'official' language? Until the late 1970s, most signs were in the stereotyped Ministry of Works Trajan capitals used for all public monuments. These signs were, and often still are, signwritten, though for some of the parks a system of screen-printed signs using the typeface Century is being adopted. Where signwriting is usual, continual repainting is necessary. In Richmond Park since the late 1970s the non-vernacular Trajan capitals have been gradually replaced by a very vernacular english letterform in capitals and minuscules. Unhappily, in 1985 crude sans-serif capitals were being used. In Windsor Great Park and Virginia Water, pedestrian notices in block capitals (again too characterless to be dignified by the term grotesque) alternate, year-by-year it seems, with splendidly painted signs slap-bang in the middle of the vernacular tradition, using a rich and characterful semi-script winging direct from the mid nineteenth century.

Can we draw any conclusion from all this? It is clear that the vernacular tradition is confusingly intermingled with lettering of different backgrounds. But I *think* we can say that this is a book about lettering created by tradesmen or craftsmen who do not have to consider external, intellectualised justifications for a solution, and who are working within a tradition unencumbered with dogma or archaelogical and historical theories.

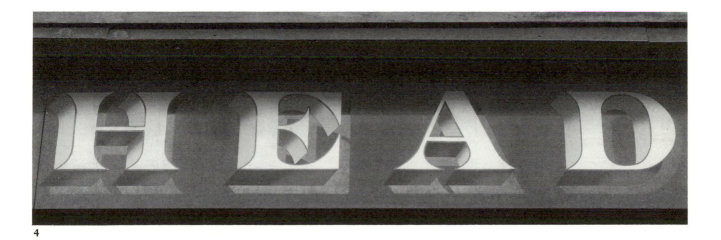

4

5

6

7

This book is divided into sections, each section dealing with a different style of letterform. I have linked each style to the century with which it can be most closely associated; thus the styles appear in some semblance of chronological order. This over-simplification gives, I think, a picture which is true in spirit if not in detail.

The following illustrations are intended to indicate the divisions I use, following the section on primitives and precursors. No hard and clear-cut definitions can be made, for the lettering men, selfishly heedless of the requirements of writers on lettering, were not always conscientious in obeying stylistic divisions. So I do not here define the styles in words, but by illustrations. Their fuller characteristics will appear in the relevant sections.

English
(5) Great Crosthwaite, Cumbria, showing the rich, classic, form.
(6) Leicester Cathedral, showing the sharper form particularly prevalent in the South Midlands.

Scripts
(7) Plungar, Leicestershire (pen-derived)
(8) Virginia Water, Surrey (brush-derived)

Clarendon
(9) King's Lynn, Norfolk

Egyptian
(10) Exeter

Grotesque
(11) Kensal Green, London

Decorative
(12) Stratford-upon-Avon, Warwickshire

8

9

10

11

12

And observe, you are put to stern choice in this matter.
You must either make a tool of the creature, or a man of
him. You cannot make both. Men were not intended to
work with the accuracy of tools, to be precise and perfect
in all their actions. If you will have that precision out of
them, and make their fingers measure degrees like cog-
wheels, and their arms strike curves like compasses, you
must unhumanize them. All the energy of their spirits
must be given to make cogs and compasses of themselves.
All their attention and strength must go to the accomplish-
ment of the mean act. The eye of the soul must be bent
upon the finger-point, and the soul's force must fill all the
invisible nerves that guide it, ten hours a day, that it may
not err from its steely precision, and so soul and sight be
worn away, and the whole human being be lost at last –
a heap of sawdust, so far as its intellectual work in this
world is concerned: saved only by its Heart, which cannot
go into the form of cogs and compasses, but expands,
after the ten hours are over, into fireside humanity. On
the other hand, if you will make a man of the working
creature, you cannot make a tool. Let him but begin to
imagine, to think, to try to do anything worth doing; and
the engine-turned precision is lost at once. Out come all
his roughness, all his dulness, all his incapability; shame
upon shame, failure upon failure, pause after pause: but
out comes the whole majesty of him also; and we know
the height of it only when we see the clouds settling upon
him. And, whether the clouds be bright or dark, there
will be transfiguration behind and within them.

John Ruskin, 'The Nature of Gothic' from *The Stones of
Venice*

All things which can give ordinary life a turn for the better
are useless: affection, laughter, flowers, song, seas, moun-
tains, play, poetry, art and all. But they are not valueless
and not ineffectual either.

David Pye, quoted in *Art Within Reach*, edited by Peter
Townsend (Art Monthly/Thames & Hudson, 1984).

1. Primitives and precursors

It seems to me that a recognisably English vernacular tradition properly began in the first quarter of the eighteenth century. But lettering earlier than that has features possibly unique to, and apparently characteristic of, these islands. Vernacular lettering by its very nature is likely to be ephemeral and much more must have been done than has survived. Most survivals are, inevitably, carved in stone. Such are the small pieces set over doorways or in walls of ordinary houses, which commemorate the date of building, or the builder, or the owner; these are most frequently found in the north of England. More important are tombstones, although relatively few have survived from before the eighteenth century. Monuments put up *inside* churches are more numerous and better preserved, but they usually have a status which places them outside the vernacular.

The early examples shown here, although they are usually prosaic, and can rarely be called sensitive, reveal some conscious attempt to create a controlled and particular conception of form. Sometimes primitive in conception, and sometimes clumsy in execution, they are evidence of a struggle to achieve an idea. I would not call them naive. There are many examples, which I have excluded, which are almost childish scrawls. These have their own charm and vigour, but are irrelevant. My examples show the English craftsman inventing lettering for himself, trying to create a unity of formalisation, relating one letter of the alphabet to another, and seeing, also, the word, or phrase, or complete inscription, as an overall interrelated pattern.

Throughout the history of lettering, form intimately relates to technique. The form of Roman lettering was dictated by the way it was initially drawn on the stone with a square-ended tool, then carved with a sharp chisel. Both tools affected the form. The design of type was not only the result of the wishes of the time, but was also governed by what was printable at that time. Sometimes techniques were developed to enable the desired forms to be properly printed; sometimes the form was designed to suit existing techniques. The two advanced together. And with vernacular lettering, whether a form is drawn, engraved, carved; what material it is carved in; what

techniques are available, or affordable; social preferences, prejudices, demands; usage and function; these all affect form, and work against any attempt to provide a simple pattern of development.

Since the surviving early examples are mainly cut into or out of stone, we are seeing only the lettering of one medium. (Any signwritten lettering apparently older than twenty years or so must be treated with suspicion – has it been repainted, if so, how accurately?) However, even in the limited selection here, one small but constant characteristic seems significant. For the playfulness and invention in the shaping of certain letters are indicative of a willingness, or a desire, to experiment with the forms. While sometimes hazardous, this adventurous attitude can result in new forms, and ensure that the tradition avoids death through sterility. At its worst it becomes whimsey, but at its best it is exuberance, an expression of pleasure and interest by the craftsman in his craft. Such, for example, were the decorative flourishes, often extending the ends of letters: a favourite device of the early letterers, influenced perhaps by the writing masters of the late seventeenth century.

The lettering in this first section is the lettering of a rural England: a country almost impossible to imagine today.

The English vernacular tradition in lettering grew up as England grew up. Early in this period emerged the first hazy outlines of a country which we ourselves can recognise as having, in embryonic form, characteristics we still think of as English. As these characteristics became more pronounced, they were joined by others which, while often less pleasing, are equally important.

The English lettering tradition grew up alongside the English people, for good or ill, period by period. Each style was a reflection of its background; each form was, usually, quite slowly developed to meet new needs, although sometimes a style would be stolen for quite different uses from those for which it was originally intended. Each new style was an *addition* to the tradition, it never *supplanted* an old style. And in our day, in our way, we still use these styles, adapting them to our needs and tastes.

20

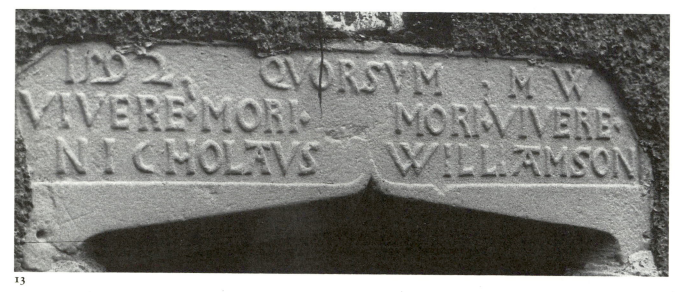

13

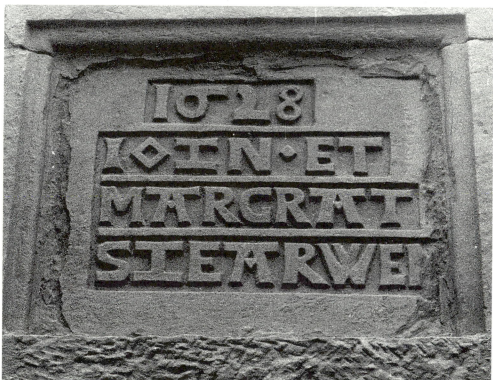

14

The majority of the date or lintel stones in the north of England show merely the year and initials; these two in Cumbria, (13) at Millbeck, (14) at Gosforth, are more informative. Both use carefully shaped letters which, as with so many of these earlier examples, are in relief, involving the arduous hacking out of backgrounds: a technique more suitable for wood than stone. The characteristic form of the A persists until the end of the seventeenth century. But, early though these examples are, they show several features which will recur constantly throughout the development of English lettering: the overall sturdiness and strength; the fairly regular and square proportions; occasional idiosyncrasies in the form; and willingness to twist – literally, in (14) – the letters for the sake of pattern. They are both as far removed from Roman lettering, or the lettering of the monasteries or Renaissance forms, as it is possible to get. The forms in both examples seem more carefully wrought and more confident than those in any tombstone of the period that I have seen.

Serifs are a technically neat way of terminating the stroke; but in (15) from Galway Town, they have been a bit of a struggle to achieve in this relief form. The bowed leg of the R, seen also in (13), will be met repeatedly throughout this story.

The date stone from Lostwithiel, Cornwall (16) follows the same general form, as does the example from the altar in the old church of St Martin, Martindale, Cumbria (17). Unlike the others here, this is carved in wood – a tricky although more tractable medium, allowing freer forms – similar to designs found on many contemporary bread or spice cupboards in this region.

15

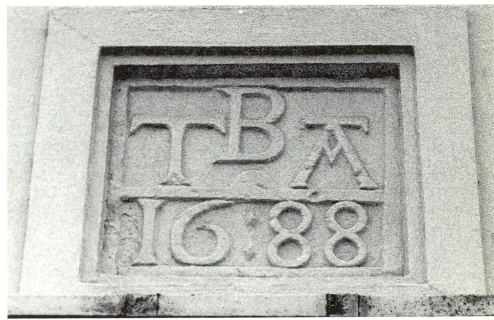

16

17

The two cast-iron tomb 'stones' from Wadhurst, Sussex, in the one-time iron-smelting region of the Weald, show a purely English design (**18**) alongside traces of almost-forgotten Renaissance forms (**19**). This second example is altogether more stylish although the date is one year earlier. There is a more sensitive if not always consistent relationship between thick strokes and thins; rounded letters, especially D, G and B, are better formed; the A, despite the bent crossbar, sports a faintly Renaissance air, having discarded the top horizontal stroke seen in (**18**). The R has the concave leg of Italian forms, instead of the straight form seen in (**18**) or the convex shape in (**13**) or (**15**). Serifs are more refined than those in (**18**) where, as in many early examples, they form a blunt triangular swelling terminating the strokes, rather than a true serif.

With the third cast-metal plate here, (**20**) from Saltash, Cornwall, we are back again in the mainstream of English lettering. It uses what is virtually a sans-serif, and gives the impression that the mould was cut out of clay. I find it, despite its naivety, a very pleasing design, with sudden enlivening letters such as the Y, the variously-shaped Rs, the angled cuts to the horizontal strokes of the Ls and Ts, and its very narrow Es.

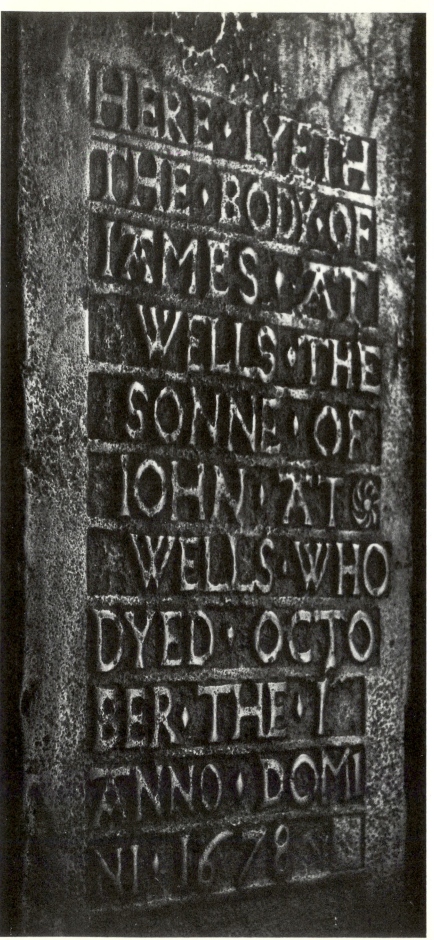

HERE LYETH YE
BODY OF IOHN
ABAN THE SECO
ND SON OF EDWA
RD BRABAN OF S
ALEHVRST WHO
DIED MARCH THE
1677 AGED 18 YE
S AND 3 MONT

19

THIS CHAPPLE WAS REPAIRD
IN THE MAIORALTY OF MATTHEW
VEALE GENT ANNO 1689

20

21

22

Forms became more assured by the early eighteenth century. A stone of 1667 at Bradford (21) shows the transition. (The slightly odd effect in this photograph is because rainwater has filled the incised V-cuts.) The letters are quite regular in cut and proportion, with reasonably competent serifs. The As still have a top cross-bar; the M is an interesting attempt to tackle a letter which can either look awkwardly wide, or squashed and cramped; the Rs have a splendidly bowed and curly leg. Only the Y reveals real uncertainty – is this because it is not a common letter, I wonder? Some strong tradition seems to keep the U as a latinised V, and J as I.

The other three here, of well into the eighteenth century, are all from Hickling, Nottinghamshire, in the Vale of Belvoir. The most primitive (22), dated 1732, is cruder than (23), dated 1719. I feel (23) and (24) could have been done by the same man, although eighteen or nineteen years separate them; but (22), even if from the same workshop, was almost certainly by a different craftsman. Even the later one is still cut in relief – although minuscule letters on the same stone, which can be seen in (37), are incised.

The letters in (22) are no advance on (13) of a hundred-and-forty years earlier; but both (23) and (24) are from a different world. Much more care has gone into the relationship of thicks to thins and the formation of serifs. The forms of the C and R, particularly in the earlier example, show a real feeling for the form and a sense of fun too. Here is the swirly leg of the English R in early glory.

23

24

Either there were several workshops operating in the Vale of Belvoir, or the one at Hickling employed several men with distinct styles. The world-weary angel – of Death? – at the head of the stones, who has obviously seen it all before, is very similar throughout – compare (23) and (24) with (25) here, from Long Clawson, Leicestershire; but this stone has very different lettering, although it is also dated 1738. However, the minuscules of (24), seen in (37), resemble those of this Long Clawson example in many ways – and they also use the same text. So it does

rather look as if these two stones, at any rate, are from the same shop, if not by the same man.

The example here is my first to show definite influence of the work of writing masters. Similar loops and flourishes can be found in Cocker's samples of sixty years earlier, and there is little doubt that the decorative initials on the left are derived from the same or a similar source, even if they have been somewhat simplified. The flourishes are carried through into the minuscules and the opportunities offered by ascenders and descenders are exploited. But such decorative fun and games are not solely the result of looking at writing samples; they are an innate part of English lettering, constantly reappearing. Here, one feels they result from a new-found realisation of the possibilities inherent in the craft. These forms are not an unimaginative attempt to *copy* existing work, but an enthusiastic transformation, building upon the source. The larger scale is exploited in such details as the charming coupling of flourishes, or ascender and descender. These, together with the contrasting of a curly descender winding around a straight ascender; the S-shaped cross-bar to the A, like a schoolboy's belt buckle; the curly finish to the top of the long stroke of the y; the holes drilled to end some but not all of the flourishes to the capitals; even the sudden dropping down to minuscules in mid-name; these suggest the delight of new discoveries, inventiveness, adventurousness, a somewhat whimsical humour, and, above all, enjoyment.

As far as form goes, these letters can hardly be called precursors. There is a rhythm and elegance we have not seen before. And despite the undoubted influence of the writing masters these are carved forms, not pen forms. There must have been a copybook lying around somewhere, but I don't think it had been looked at for a long time.

Three lintel stones from northern England: (26) from Worton, Wensleydale, (27) and (28) from Lowther Bridge, Cumbria, all show, despite their simplicity, the English fondness for pattern-making letterforms. The swelling 1 in (26) is frequently found, created in various ways; a kind of braided form is common. The 8 in (27) is oddly effective between the spiralling 6s.

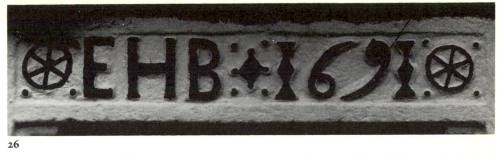

26

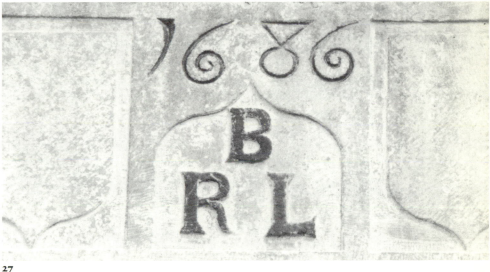

27

28

Further examples of decorative effects are again from the Vale of Belvoir or thereabouts. (29) is from Granby, Nottinghamshire, (30) from Grantham, Lincolnshire, and (31) from Nether Broughton, Leicestershire. They all show an awareness of the pattern-making potential of ascenders, descenders and capitals, their careful interlocking further enhanced by

29

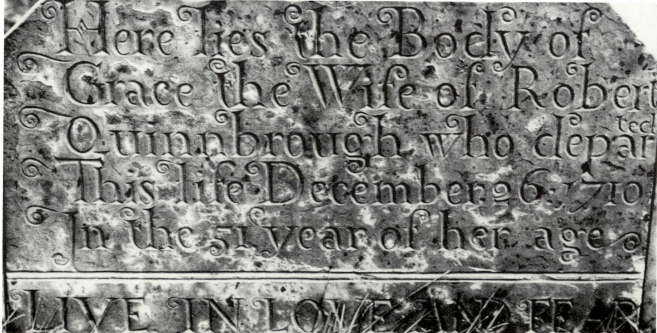

30

the insertion among them of small letters. If one had any doubts as to whether these strongly-cut forms were at all influenced by the writing masters, the decorative H in (29) is the give-away, as, to a lesser extent, are the swash capitals elsewhere. But the minuscules, once again, have moved far from such sources. Here are my first completely upright minuscules, taking them even further away from the copybooks. Note the true upright form of a and g in (30) and the lower half of (31) – although judging from the first a there, this version did not come naturally. The distinctive form of W can be found in those copybooks, however; it also appears in my examples from Cumberland of around 1740–50.

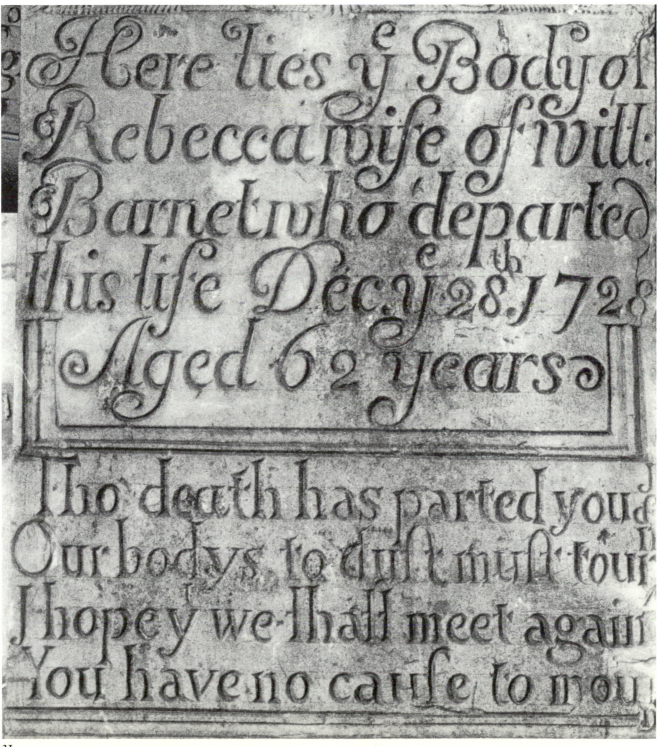

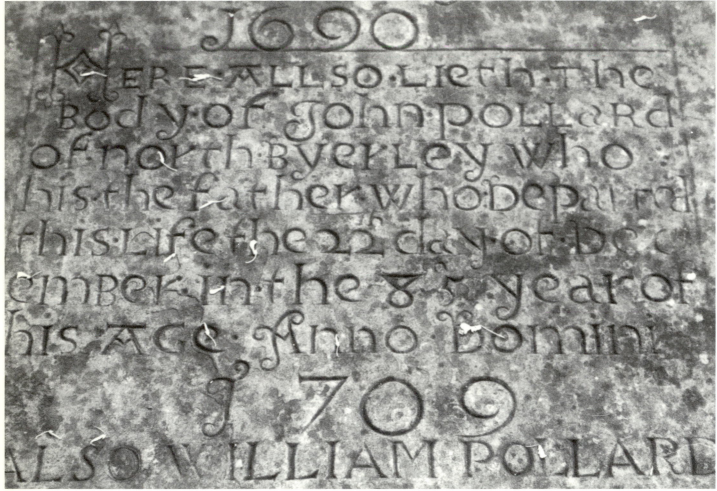

32

But it is difficult to make sense of it all. While all that was going on in the South Midlands (and much else besides, as we shall see), things were very different in the North. The willing but confused carver of (32) at Bradford, Yorkshire, has jumbled up a mixture of capitals and minuscules and included an archaic form of A, the strange form of 8 seen previously to better effect in (27), Ds with a tiny flourish like a bean-shoot struggling up through the earth, and much else. What could he have been looking at as a reference? I don't think he had ever seen a copybook in his life, although he had obviously seen flourished letters somewhere. But he uses the true upright a. Even the Belvoir carvers did not always do that.

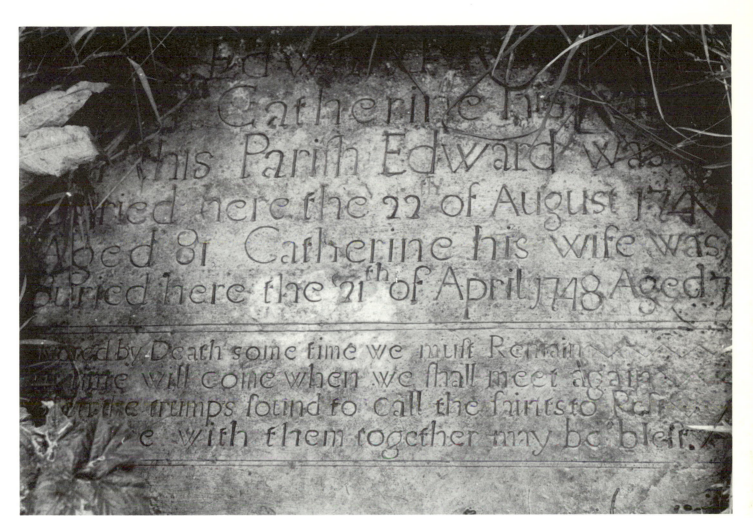

33

Nor were they always much better in the West Country. (33) from Lanivet, Cornwall, is unexpectedly rough for its date. It appears unaffected by the writing masters, and would seem to be a backward manifestation of the West Country carvers' own progress towards the english letter. Better work was being done there at this date, although it was generally far behind the work of the South Midlands men.

Unskilful work can of course be found in all periods throughout the country. Admittedly, the Bradford stone seen here is rather earlier than most of the Belvoir examples we have been looking at; but while it *is* a mess, it is also evidence of a totally different conception, both of lettering and of arrangement, and no devel-

opment of it would ever resemble the Belvoir letters. Compare it with (30) of one year later. But, unlike the Lanivet stone above, which is cut without enthusiasm, skill or understanding, it shows imagination, and potential. It is not lack of interest that holds the carver back, but lack of knowledge. It is far more ambitious than (33). Many of the letters, individually, are well conceived and well-executed – particularly the capital letters; and a certain pleasing overall pattern and texture emerges. The much later West Country stone, on the other hand, is simply incompetent.

It is apparent that the craft of lettering progressed throughout the country in a very erratic way.

2. Eighteenth-century elegance

The english letter

The rock upon which the whole of the English vernacular tradition is built is the style I have called english.

I have shown its early development solely on tombstones because little else exists from this period. And because the development took a different form in different parts of the country, I have had to accept this too and break it down into several regions: the South Midlands (Leicestershire, Nottinghamshire, Lincolnshire, Vale of Belvoir); the West Country; Lancashire and Yorkshire; and Cumberland. The story is further confused by two parallel developments in the South Midlands.

These areas are blessed with stone that has on the whole not badly decayed. Other regions probably had equally good but now almost indistinguishable lettering. That which *is* still distinguishable does not, however, contradict, nor even add greatly to, the developments shown here. One need not be surprised that the best lettering developed where the best stone occurred.

Much – I think, too much – has been made of the writing masters' influence upon the tombstone carvers. Probably the first relevant master was Cocker, whose specimens were published around 1670; and from 1680 to 1741 hardly a year passed without other masters issuing specimens. Until the early years of the eighteenth century, the hands were fairly rounded, not excessively inclined, and often not true scripts – the letters did not always link. This style undoubtedly affected some of the early forms of english letter. Many examples, cut in the first forty-five years of the eighteenth century, can be found in the Vale of Belvoir, and a few elsewhere. But, confusingly, these early Belvoir forms grew up alongside an alternative form, more closely related to the spirit of later writing masters' scripts (culminating in Bickham's, whose compendium was completed in 1741). These writing examples were more condensed, more inclined, had a sharper contrast between thick and thin strokes – all resulting in a far more 'up and down' look – and were completely linked: copperplate as we know it.

There is little doubt that the copperplate *scripts* seen on stones throughout the country, the scrolls and flourishes, and the decorative headings, all come from sources such as Bickham; so do many of the decorative letters; and so

do the undecorated capitals, though usually (for most of the eighteenth century) in a slightly lighter form. This 'borrowing' was far from mindless copying. It is usually difficult to translate lettering of one medium into another without modification; and these carvers had too much pride in their skills to do so anyway. They made considerable personal contributions. Only in the copperplate scripts did they rely heavily on the originals; here the techniques of engraving and chiselling were temptingly similar. These specimens were latched on to remarkably quickly.

The origins of the upright minuscules are much less clear. When we look at the more prevalent and longer-lasting of the two South Midlands styles, we would initially assume it to have been influenced by the later writing masters, for the overall designs of the stones, with their abundance of flourishes and scripts, tell us that the carvers had the copybooks in mind, if not on their workbench. Yet, while upright minuscules were the staple letter of the carvers in all regions, they were not an important feature of any copybook. When they did appear they were smallish, less assured, and less well-drawn than the scripts or the capitals (it is a form which is quite difficult to do on a small scale). Although the brilliance and sharp differentiation between thicks and hairline thins seen on the pages of the copperplate specimens were reflected in the minuscules on the South Midlands stones, it seems to me that here the carvers, building upon what are virtually no more than hints of a new form, themselves did all the real development work, organising the letters into a truly inter-related alphabet.

The particular form of english letter, with its unbracketed serifs and hairline thins, which developed in the South Midlands, seems to have ousted from there any other form of upright minuscule. It developed quickly, became more assured, more skilful, more regular; it made the 'Cocker' form of the same period and region look very peasanty, unsophisticated, out-of-date, *unfashionable*; and then it froze for a hundred years or more. By the 1840s it had been around too long, and the quality of its cutting deteriorated. But in its youthful vigour it was immensely important, for at the peak of its development Baskerville copied it and turned it into his much admired and very influential types. Carved examples can

be found which predate these types by over twenty years. And although his designs as printed are rather bolder than the carved forms, if types cast from his matrices are printed without the ink squash of letterpress, but by today's techniques – resulting in a lighter and sharper image – they are even more faithful to the carved forms than the pages of his books.

Later types of around 1780, being cut more sharply, resembled yet more closely the South Midlanders' lettering of forty years earlier. At this point, stone carvers and typecutters seemed to be travelling on opposing courses. For when carvers other than South Midlanders were almost entirely using a richer english form, the tendency in type design was towards a more abrupt contrast between thick strokes and the new hairline thins, resulting in a drier-looking form. This trend culminated in the hairline-seriffed moderns of Didot and Bodoni; although, significantly, English type designers never took the development to the extremes of French, Italian, or German designs.

It is dangerous to make definitive statements about such developments. In the eighteenth and early nineteenth centuries, local traditions stayed local far more than they do today, for travel was difficult. The picture is further confused by regional variations, by local materials, by local, workshop or family traditions, by degrees of inventiveness, awareness or skill in individual craftsmen, and similar obstacles in the path of the pigeon-holing historian. In the end, I wonder if it matters very much if we never find out precisely what happened. I suspect that, in reality, many so-called local styles are merely one craftsman's style – sometimes influencing a small workshop.

These skills were the direct result of the importance given to handwriting in Georgian times, which not only formed or affected the abilities and styles of all lettering designers, but – perhaps even more important – created the general appreciation of, and demand for, handsome lettering.

The richer form of the true english letter, which developed outside the South Midlands, seemed initially the result of bolder thick strokes and deeper carving, allowing the V-cut to read more strongly, particularly at the junctions of thick strokes and serifs. This, as can be seen in the photo-graphs, gives the appearance of bracketted serifs even when the form on the surface of the stone has virtually no bracketting at all. There had often been signs of true bracketting on the carved *capital* letters, just as it had been apparent in the writing masters' roman capitals. It appeared on all letters in type, including designs by Baskerville and succeeding typecutters. But, as types began to lose their brackets in their development towards a sharper design, the vernacular letterers, contrarily, often used them more positively.

I believe the full character of the english letter is the result of some innate prejudice asserting itself. Even in the late seventeenth century, English lettering displayed individuality. The development of the particular english form, which shows great variety within its basic pattern, was spread over a long period, and it continues today. It was also broadly spread geographically, covering the whole of the British Isles. It seems almost unaffected by writing masters after 1740.

The early forms in the Vale of Belvoir were already bolder than the sharper forms which were developing alongside, and in the overall design of the stone the carvers usually made skilful use of ascenders and descenders: a different vocabulary (though achieving much the same ends) from the calligraphic scrolls and flourishes of the copperplate-inspired stones. In these early years, its development was more hesitant than the swift and sure advancement of the alternative form which, in the Vale, killed it off.

The work of Cocker and his fellow writing masters was the seed from which the english letter grew, not only in the Vale of Belvoir, but other regions too; and it was eighty years or more before the style found deep enough roots to enable it to become completely independent of any echo of these sources. (Such influences lingered longest in the decorative capital letters.) But from the beginning the lettering underwent considerable transformation during translation into stone. Flourishes were simplified, strokes were bolder, with less contrast between thicks and thins. There is none of the almost exact translation of later pen or copperplate scripts into carved forms. In regions other than the Vale of Belvoir, the direct influence seems slight, even debatable. The copybooks probably gathered dust for long periods on the carvers' shelves.

Many of the forms were gently italicised, as were the written forms; but as the carvers became more assured and independent, the letters became more – or completely – upright; until by the second half of the eighteenth century they were certainly off on a journey of their own. Decorative letters and flourishes were still derived from the copybooks, but the main minuscule letterform was by now a quite independent creation.

The West Country carvers appear to have been almost entirely unaffected by the writing masters. They seemed to progress from some rather clumsy lettering of their own devising – which sometimes related more closely to the sharper South Midlands form than to North Country styles, but which nonetheless always held the germs of english forms – gradually refining it until, about 1830, they began to use type specimens as inspiration for new forms when some special effect was wanted. In the north of England a few stones show some slight influence of the early writing masters; but again the upright minuscules are the important letters, and here I can see nothing to suggest the carvers were affected by anything in the copybooks except a few Bickham-like decorative headings and scrolls. From some confused and painful early struggles which suggest that the carvers had rarely seen letters before, and could scarcely remember what the sodding things looked like, the forms grew in their own sweet way to evolve into some of the finest english letters of all. As far as the vernacular is concerned, this could be where the most important development of the english letter occurred. There is no suggestion of writing masters' forms, no echo of type design. Nor, that I can see, did they themselves – unlike the South Midlands forms – influence type. They are simply fine carved forms. To my eyes they have a northern sternness – worlds away from the work of the namby-pamby southerners, or the isolated and dreamy West Countrymen.

I have concentrated on tombstones to describe the early development of these forms partly because they survive in fairly large numbers. They are also dated. These dates can be traps: they are the date of the deceased, not necessarily of the carving, which could be done many years later. It would be very rash to base a chronological development on one or two examples, but if enough stones indicate the same story, we can take it as a fairly reliable guide. There *can* be no strict chronology, with the differences of ability and adventurousness so evident in any craft. We can only ever concern ourselves with the general drift. My selection of pictures may have simplified the story, but I hope the tale is essentially accurate.

The full vigour of the english letter came after many of these stones were cut. It can be seen in its prime, in capitals only, in the street names of Bath, carved direct into the string course of the buildings. It also appears as cast letters, as three-dimensional stock letters, and as perhaps the most important basis of signwritten lettering. It grew up in the period of English history we most associate with fine, straightforward craftsmanship – Georgian silver, Adam, Wedgwood, Chippendale chairs. It is the eighteenth-century letter *par excellence*, displaying all the elegance, taste, moderation, good manners, and care of detail we associate with that century; but it is still today in these islands a very potent force, far from played out.

I think the reason for this is that its character reflects (a perhaps ideal conception of) the English character so accurately. It is not extreme in any way; it is unpedantic, untheoretical, practical, empirical, robust, vigorous; it has no self-conscious aestheticism, but an uncontrived elegance. Perhaps most important, it seems to accept a wide range of personal interpretations without losing its excellence. Its proportions are beneath all later forms of English lettering, even egyptians and grotesques. It is a native growth, and thrives in its native land.

34

We have already seen several Belvoir stones. A further short sequence demonstrates how completely they belong to the early development of the english letter, even though this particular strain was mysteriously aborted about 1745. From some primitive beginnings in the area the Belvoir men developed their own individual designs. For thirty-five years they gradually refined them, whilst often, at the same time, incorporating certain early characteristics unchanged.

The two stones here are from Thurcaston, Leicestershire – about ten or fifteen miles from the Vale. In (34), some source of lettering has been referred to, almost certainly the copybooks. The swirly initials and occasional flourish to the italic letters indicate this. But there is much here which is personal, possibly because of insufficient skill to copy properly the writing specimens, and several features suggest the english letter. More has been attempted than just carving out the message: some impulse to organise the stone and create a pleasing and lively overall pattern with a certain individuality has been at work.

The lettering in (35) is very near to that on the Belvoir stones, even if the arrangement is more banal and loose. It has the boldness of the previous Thurcaston design, common also to the Belvoir ones; its roundness and richness, also shared, is a characteristic of the english letter.

And here it is, the Belvoir form that died so young – about the age, in fact, of those commemorated here. It was far from a single, ever-repeated form; it had much more variety than the South Midlands letter we will be examining shortly, which developed alongside and which thrived four times as long. The upright and italic of (36) from Harby, Leicestershire, are slightly condensed versions of the regional style. Some serifs are horizontal, some slanting, but they are all bracketted. Writing masters' copybooks have been found with the names of stone carvers written in them; but this chap, if he ever owned one, had not opened it for many a year. This example is more severe than the similarly condensed lettering in (29); in fact, one of the most severe of all the Belvoir stones. Yet it is essentially a Belvoir letter.

A more elegant and lighter version is seen in (37) from Hickling, Nottinghamshire. This is the lower part of the stone seen in (24). A very rounded form, it reflects more closely the general style of the copybooks, but the process of carving has given it a less fluid look. There is no hint of any linking up.

At Granby, Nottinghamshire (38) this lettering of the 1720s, with its richness of cut, strong serifs, and confident air, is in some ways surprisingly similar to that on the much later North Country stones. Typical Belvoir flourishes and spirals enliven it; the B and R are especially attractive. Compared to later lettering, the line of capitals, despite the enlivening Rs, is a little pinched-looking.

A second example from Hickling (39) has many similarities with the first (37) of six years earlier, and could well be by the same carver. It has gained a tightness

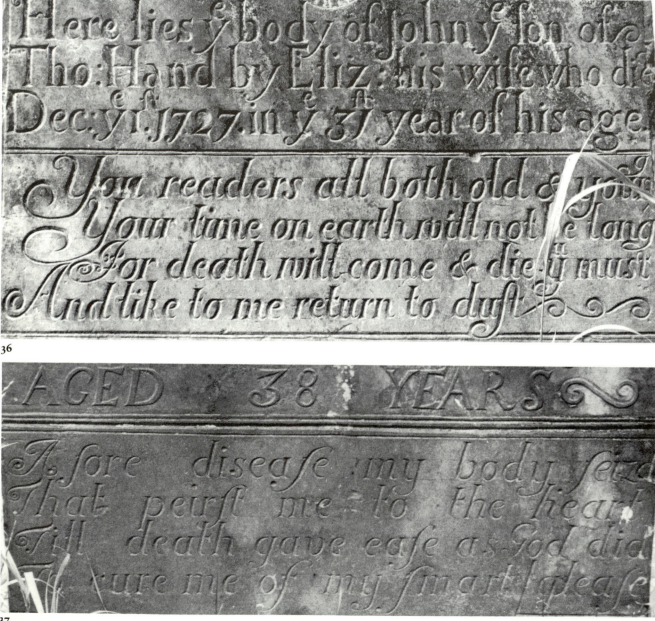

36

37

of letter-fit and word-spacing, and is yet fuller and more rounded. Ascenders are on the whole shorter. Compared with (31) at Nether Broughton, this Hickling letter has become less of an italic – really, a sloped roman. It is lighter, freer, more confident and more elegant. The playfulness with capitals, decorative letters, and flourishes does not suggest the carving had become in any sense a routine. These letters are in the springtime of their life. Yet now they die, suddenly; completely wiped out as if they, or the men, had been struck by the plague.

The distinctive style of these Cocker-influenced letters lasted from about 1710 to about 1745. I have seen nothing like them elsewhere. They show a slow progression of form, and big enough variations to suggest that they were either the product of several workshops scattered around the Vale, or of one large workshop employing several quite independently-minded craftsmen. One guesses that several generations were involved. Suddenly it all stops. Thirty-five years could be the working span of a man's life in those days when (one has

only to read the stones) death often came early. Were there no sons to carry on the business? Why did none of the other craftsmen take it on? What happened?

What happened in the Vale of Belvoir at any rate is the sudden cessation of this line of development. Nothing like these forms, still showing some influence of copybooks of 1670, was to appear there again. Or anywhere else, that I know of, in so pronounced a way.

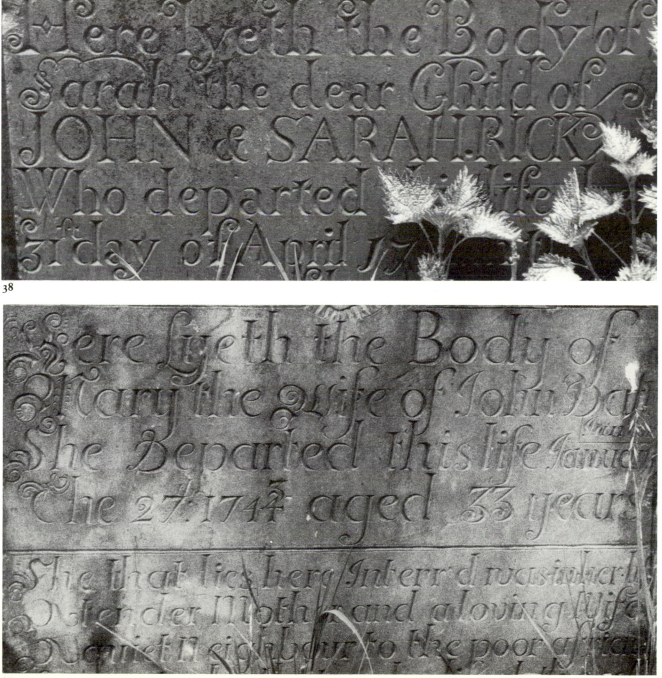

38

39

At precisely the same time, and in the same district, as the Belvoir stones were being cut, a very different style was developing. I shall call it here the South Midlands form, to distinguish it from those Belvoir designs we have just seen, since it covered a broader geographical area than they. It can however be seen in the Vale, in the same churchyards as those Belvoir stones. It developed into a sharply-cut form of the english letter, but here we see it in a very early state. A stone at Thurcaston, Leicestershire (40) could almost be called the common ancestor of this sharp form and the richer design which developed in the north of England, for it has the elements of both in embryo. Its boldness, roundness and deep cutting relate it to the latter, but its fine horizontal serifs – a very prominent feature – belong to the South Midlands. Copybook influence is apparent in the first word and the flourishes, but the upright minuscules are original, as they are in (41) also at Thurcaston. The letters here have moved closer to the classic South Midlands form, and further from the northern letter. The more sudden gradation from thicks to thins emphasises the verticals, reducing the apparent roundness and giving a more up-and-down look. Ascenders and descenders have grown, increasing this effect. I suspect these two were done by the same man.

A third Thurcaston stone (42) is probably by him too. The changes are minor but significant. To all intents and purposes they have merely emphasised the previous changes, but they all move in the same direction. This design is more deeply cut, and therefore bolder, than the later styles; the serifs are a little awkward, stuck on to rather than terminating the

stroke (and with an occasional 'sport' as in the bottom serif of the d). But the letters fit closer and more rhythmically than in (41), and the overall design of the stone has become a little more ambitious. The initial word retains the wonderful series of swirls seen in (40).

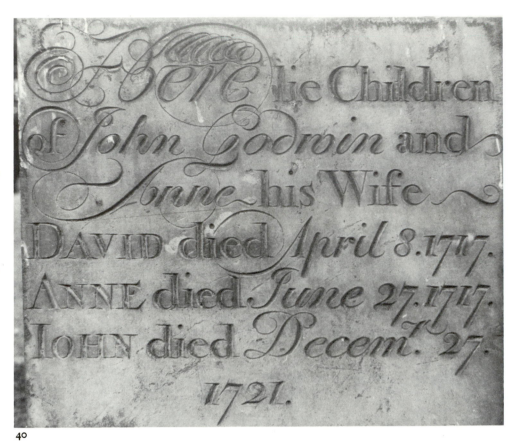

40

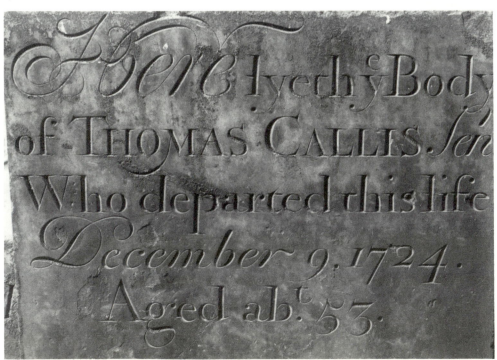

41

The script letters in these early stones are noticeably better than the upright minuscules. The carvers were able to copy, or adapt, fully-evolved models of the former from copybooks; but the latter had to wait until the carvers themselves had worked out the form. For, unlike those of the scripts, these are not shapes that derive naturally from the movement of either the pen or the chisel. They require a slower, more considered technique, the form being built up, I might say intellectually, rather than achieved by mechanical skill or virtuosity.

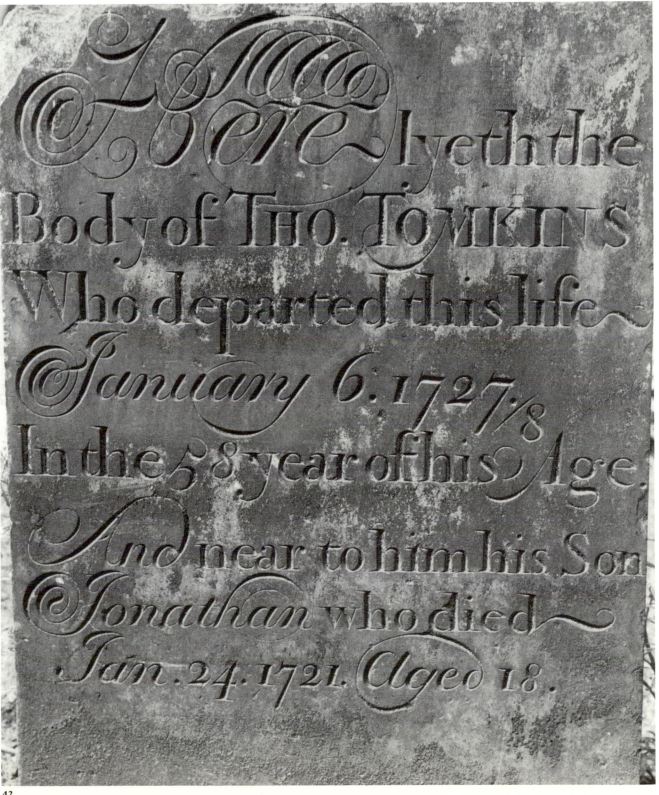

A fourth stone from Thurcaston (43) shows this form evolved in all essentials, although it is a few years earlier than the previous two. I suspect it was by a different carver, though from the same workshop. It is a surprisingly early manifestation of the form. It differs from the others mainly by its lighter weight: a change which is probably responsible for the more refined serifs. We are getting a more sensitive letter here.

An amazingly accomplished and precocious example (44) from St Mary Castro, Leicester, is almost the climax of this form, usually not seen until about thirty years later. The design of the stone suggests the date of carving *is* the date seen here. This is the kind of lettering Baskerville must have seen – and possibly cut – before designing his types. The italics and the flourishes are straight from some source such as Bickham, but the minuscules, I believe, are the result of steady development entirely carried through by the carvers. Only on the larger scale of tombstone lettering, or in the intensive and specialised world of typecutting, can such careful and thorough interrelationships be worked out. And these letters were not initially evolved by typecutters, whatever may have happened later.

This example shows the delicacy and elegance of the sharp-cut South Midlands form at its best. The balance between the thicks and the now almost hairline thins has been carefully judged, while the capitals are perfectly assured, curve flowing beautifully into curve, or meeting the straight strokes without fuss or weakness. The bowed leg of the R has grown a splendid flourish.

An example from Leicester Cathedral (45) emphasises that the course of lettering is no simple affair, for although this stone is dated three years later, it is, in feeling, ten years earlier. While clearly in the South Midlands style, it has been cut by a less skilful man. The italics and flourishes look a little out-of-date, too. (Even here, however, the source is probably nearer to Bickham than those the Belvoir carvers were using – *they* never bothered to replace their 1670 or so specimens, even if they remembered they still had them.) Despite some lack of skill, we are in a different and, one would guess, a more fashionable world. It was however the overall design of the stones which made the Belvoir letterforms appear more archaic than they often actually were. Developed from an earlier stock, they would certainly have grown into something quite different from these we are now studying: compare (39) with (44) and onwards – and make your own guesses.

43

Here lyeth the Body of
GEORGE DEAN who departed
this life May the 27th 1734.
Aged 48 Years.

The toilfome World he left behind,
A Crown of Glory for to find.

44

Here
lyeth ye Body of DOROTHY ye
Wife of John Goddard who
departed this life August
31st 1737. Aged 41. Years

45

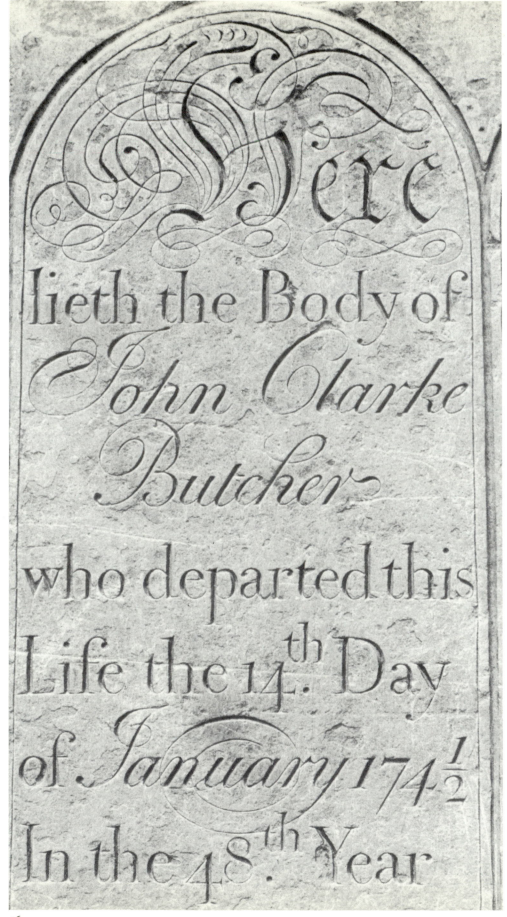

What the South Midlands form grew into, can be seen in the next few examples. Once achieved, it did not grow into very much. Earlier on, a few personal variations were cut, but these variations seem the result of imperfect skill rather than intentional developments. Such is (46) from Loughborough, Leicestershire, a pleasing letter if less perfect than (44) which it closely resembles. The italic and the flourishes are more restrained, and it is possible that the stone, which looks less fine-grained than the slate of (44), is responsible for this subdued effect.

The unusual form in (47) from St Nicholas, Leicester, could have been taken for a precursor but for the date. It is clearly within the regional style, but the idiosyncratic angled serifs, with extensions on both sides of the stem, and the slightly awkward cutting of the a and e give it an original character.

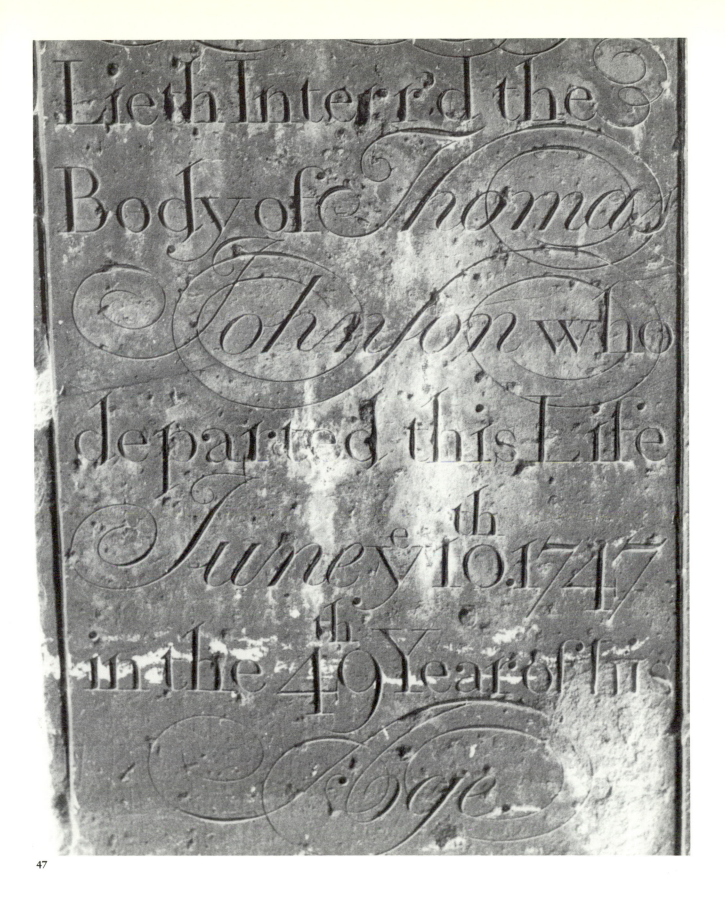

Lieth Interr'd the
Body of Thomas
Johnson who
departed this Life
June y 10. 1747
in the 49 Year of his
Age

The two on this spread are of more classic form. The slightly hesitant, sensitive cutting of (48) at Woodhouse, Leicestershire, probably results from the carver's inadequate skill. It reminds me of some of the West Country stones. It has a slightly wiry quality that is avoided in (44), where the curves have more spring and bounce, more tension generally.

An unusual version from Leicester Cathedral (49) has forms that are not only condensed, but which fit so tightly that the curved strokes of the t and a often link with the following letter. The letter widths are hardly wider than those of the italic form. This is incidentally the first appearance in my South Midlands examples of an italic as opposed to a script: compare the top line with 'Stationer'. The hooked ascenders and (generally) unlinked letters differentiate it; but the

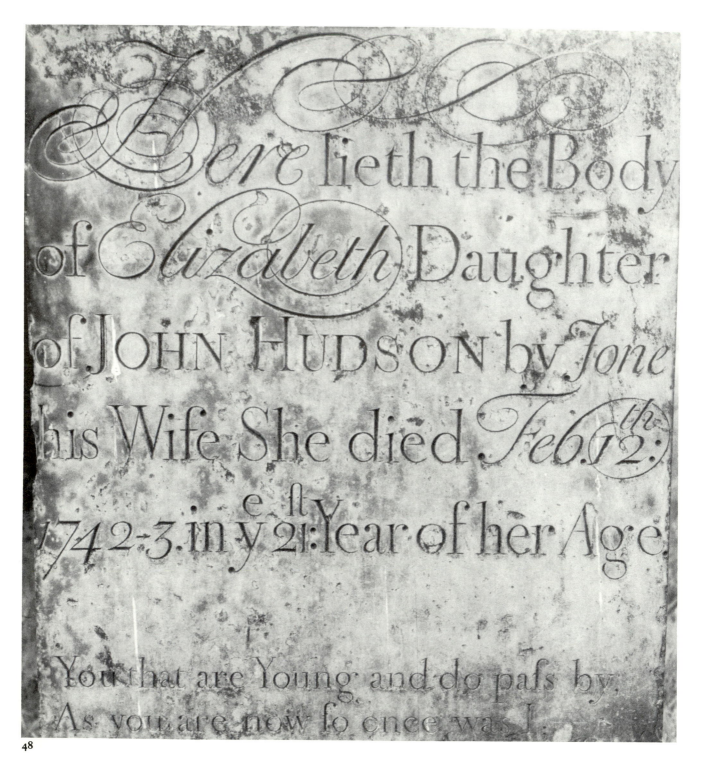

overall form is very similar. The stone
is competently and consistently cut and
the design includes an abundance of
copybook-influenced scrolls and flouri-
shes, fitting in any available space.

the Memory of
ANN, the Wife of
William Hunt;
she departed this Life
the 2 Day of October 1788.
Aged 83 Years.
Also of William their Son,
he died the 2 Day of September
1767. Aged 32 Years.
And of Joyce their Daughter,
who died the 17 of November

Another example from Leicester Cathedral (50) is typical of hundreds (it feels like thousands) throughout this area. Like most of them it lacks, I think, the exceptional skill shown in (44): the form of the a has a typical slightly pot-bellied look compared to that on the earlier stone, and the letter-spacing is looser. Scrolls swirl around everywhere, like flies on a summer day. Again we have scripts and italics (without hooked ascenders this time) looking very similar. These show a clear line of development from the copy-books.

Good though the scripts, italics, and upright minuscules were, they became a formula. And like all formulas too often repeated, they grew lifeless. Many beautiful stones were created with them, amazing virtuoso performances far better as complete designs than any shown here. But these Rococo extravaganzas were noteworthy because of the decorative motifs culled from books for cabinet-makers or architects. The carvers' energies, and interest, were exhausted by such work, and little attention was given to developing the letterform. This inter-estingly reversed what happened in the Vale of Belvoir, where the decorative element – the weary angel of Death – remained almost unchanged over thirty years, while the lettering was experimented with in all manner of ways all the time.

(51) from St Nicholas, Leicester, shows the state of the letter after fifty hard-worked years. I detect the cold wind of neo-classicism blowing around too, which does not help. I think the carver by this time was becoming a bit of a machine: there is little feeling of delight or pleasure in these letters. Even the scrolls look perfunctory: the flies are now crawling, dazed and stupid as winter approaches. Listless, the letterform continued to be used in the South Midlands for many years, but we need not follow its sad decline.

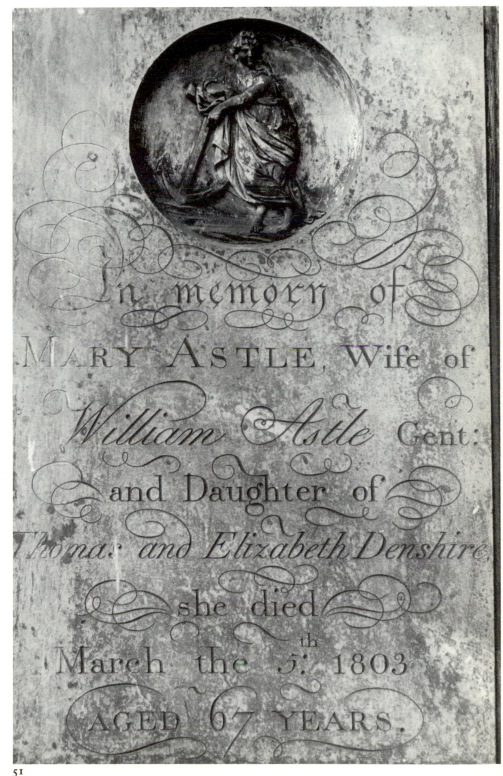

51

Goodness knows what went on at Thurcaston. The lads round about seem to have been using numerous styles simultaneously. This early stone (52) is likely to confound a lettering historian. Fortunately, this book is concerned with forms, and its author is not too dismayed if he cannot place any particular example in its precise historical context. Here we have a fine sensitive form showing some knowledge of copybooks in the swash capitals, but no influence of them at all elsewhere. While different from early versions of the South Midlands design, its overall delicacy, light thin strokes, and horizontal serifs, relate it more to this than to the Belvoir letter. But although more elegant in effect and less clumsily cut, it is also quite near in feeling to some of the West Country forms which follow.

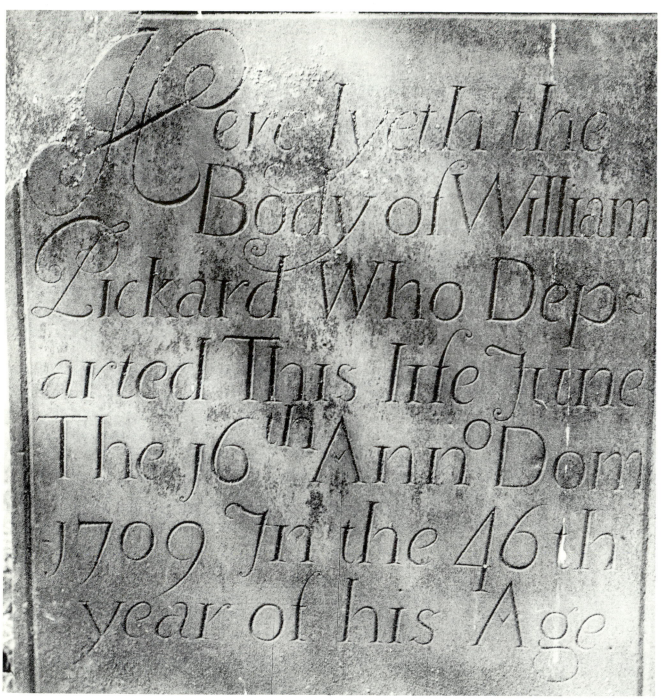

52

(53) and (54) are from Lostwithiel, Cornwall. The right-hand fragment in (53) has a boldness of cut not unlike some of the Belvoir stones, yet with a subtle but decisive difference. It is not condensed as many of them were, and serifs are barely present. I find it an interesting form with no trace of copybook influence.

The left-hand stone and (54) are obviously cut by one man, who may or may not have been the cutter of the much earlier fragment. Certain features are common: the form of the e and h, and the use of angled serifs for the l. But the differences are more apparent: lighter weight; angled serifs also for r, i, m, n; the almost Gill-like form of the a. The overall layout is casual, and the decorative initial could have been derived from any source – or none.

53

54

55

56

Here are four typical West Country forms. There is a hint of copybook influence in some decorative letters and script/italic forms; but for the rest, the carvers went their own way. This way was quite different from either of the South Midlands forms, much less assured, less disciplined, more – what? – *romantic* perhaps, more relaxed and whimsical, almost casual at times. These are not letters that could ever be a basis for type. Yet they show all the characteristics of the early english letter: richly-drawn forms, a strong and fairly sharply-graded contrast between thicks and thins, sharp serifs which are usually angled. A progressive development towards this form is seen here.

The earliest (55) is from Egloshayle, Cornwall, and has many naive features. The small hook to the a, the curly form of the e and the tendency for many letters to curl up, the serifs on the S, the irregular unskilled cutting: all these characteristics were to be sorted out later.

Only one year after this, (56) from Callington, Cornwall, is far advanced: the most advanced of these four. But for the angled serifs it might seem a South Midlands letter; and yet, it somehow is not. *They* have a more vertical stress, achieved by sharper gradation from thicks to thins, and a more consistent approach to form, more intellectual, more disciplined. At Callington, the West Country curls have not been entirely eliminated; nor is the cutting as skilful.

(57) from Great Torrington, Devon, was cut thirty years later, but is more primitive. The relationship of thick to thin is coarse; the curly e is apparent; the cutting is rough and irregular; the script letters are downright incompetent. Twelve years later, things improved. (58) also from Great Torrington shows a pleasanter relationship between thicks and thins and more regular forms, although the cutting is still hesitant. Not until they used type specimens for their source did these West Countrymen begin to approach the skill of the South Midlands cutters.

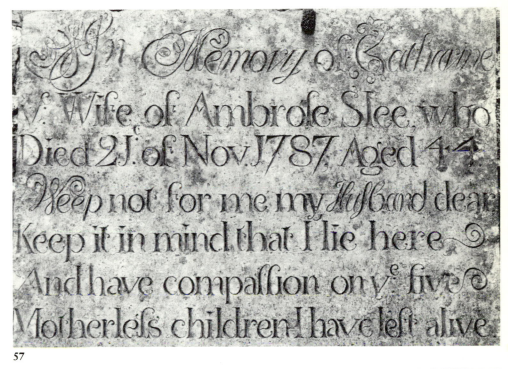

57

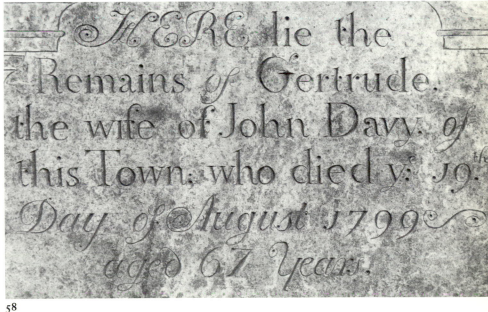

58

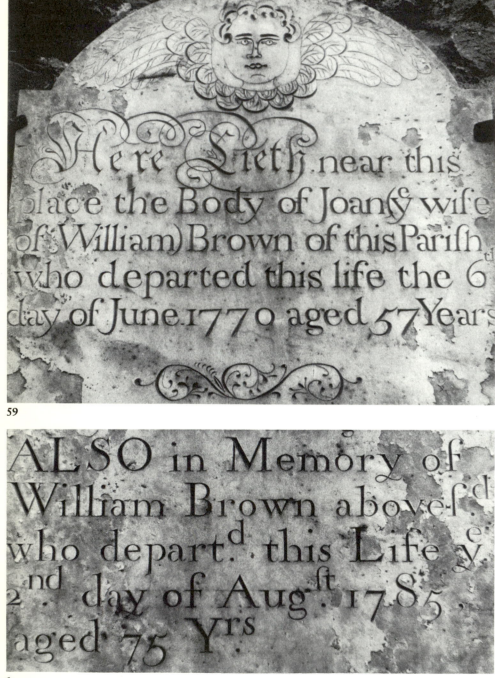

59

60

Lettering on one stone (**59, 60**) at Porlock, Somerset, is separated by fifteen years. Both inscriptions show some lack of skill but the cutting has improved. Letters are more regular, better shaped, have a better relationship between thicks and thins, and better serifs. These two show well the individual West Country development of the english letter, a version which falls half-way between the South Midlands form and the North Country, but which is rarely as skilfully cut as either.

The quirkiness of the West Country style is evident in (**61**) from Porlock, which was probably executed about 1806. Deeply cut but with quite fine thin strokes, it retains traces of the local preferences. The unusual serifs are further symptoms of a deep-seated need for curly or sprouting forms. It has a freedom lacking in the later South Midlands letter, rich individualistic form, and bracketted serifs. It is nearer to the classic english letter than anything we have seen so far.

Its ultimate development can also be seen at Porlock (**62**). The letterform here is very similar indeed to those which can be seen in the north. The capitals have certain oddities not found there, but the basic form, even the careful use of scrolls and flourishes (although perhaps less sternly controlled than in the north) is common to both regions. However, the path of development in the north was, as we shall see, very different.

In Memory of Mary the
Daught of W^m and Mary Lock
of Swimbridge in the County
of Devon who dep^d this life
Oct^r the 6th 1783 aged 18 Years.
ALSO in Memory of BETTY

61

to the memory of
JOHN
son of JOHN and MARY HUISH of
this town who died Oct^r 6th 1819.
Aged 13 Years and 4 Months.
Also Mary wife of the aforesaid
JOHN HUISH

62

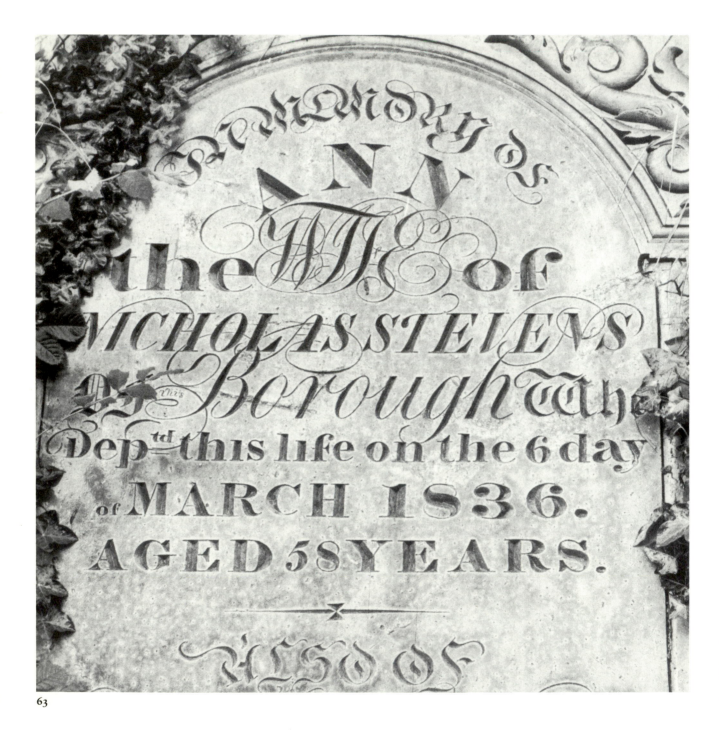

In Memory of
ANN
the Wife of
NICHOLAS STEVENS
of this Borough Wh
Deptd this life on the 6 day
of MARCH 1836.
AGED 58 YEARS.

Also of

63

About 1830 or so, the West Country carvers discovered type specimens. They were quite capable of devising decorative forms themselves, and they continued to do this, particularly exploiting shadow effects. But to a very large degree they turned to printing types, sometimes merely for the decorative headings, sometimes for the complete stone. (63) from Bodmin, Cornwall, shows the influence both of typefaces and the copybooks. The difficulty of cutting what in print is known as a modern face, with abrupt gradations from thick strokes to hairline thins, and hairline horizontal serifs, did not deter them. The skills shown here far exceed previous West Country carving, as does the standard of overall design.

Such rich mixtures of letterforms, reflecting the printing (especially the play-bills) of the time, were to become a feature of the stones in the region, although few attained the professionalism evident in (63) or (66), which in their own way match that of the South Midlands stones of nearly a hundred years earlier.

The upright near fat-face of (63) has become even more extreme in (64), also from Bodmin: more condensed, with a strong and abrupt contrast between thicks and thins or serifs. Compared to any typeform, however, the ascenders have been severely cut down – almost anticipating today's tendency. The form of the italic could have been derived from lettercarving models as easily as from types.

While the previous examples do not look out of place cut in stone, the yet more condensed modern on (65) from Great Torrington, Devon, cannot be seen as anything but a typeface, even though, again, the ascenders in the line of lower-case letters have been chopped. Also again, the italic could be in the tradition of carved forms – although the thins are *very* thin.

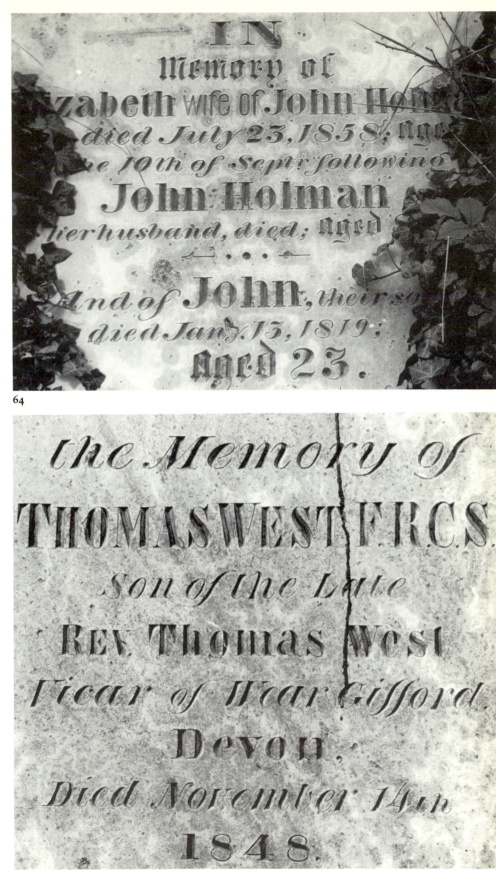

64

65

56 Finally from the West Country, another *mélée* of printing types, also from Bodmin (66). Black letter, shadow egyptian, script (from a copybook possibly, although available as type too), grotesque, lower-case black letter, italic modern, upright fat-face or decorative figures, fat-face capitals; only the italic text below could have come via carved sources.

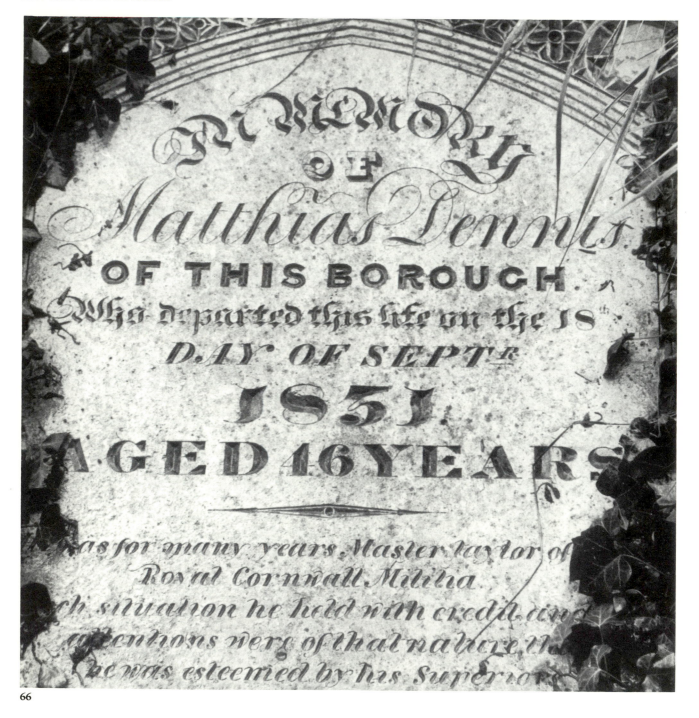

66

One of the advantages of recording the early development of the english letter on tombstones, by region, is that it emphasises how in each region the same form evolved from beginnings which were quite different in design. In each case there was a smoothly continuous growth culminating, especially in the west and the north, in almost identical forms. So the image is of roots buried widely apart in different soils, growing together to form one sturdy trunk.

I have seen nothing like this stone at Rochdale, Lancashire (67) elsewhere except in the north, where somewhat similar designs are fairly common. This one is dated 1659, and is fairly primitive. It need not delay us long.

The next six, overleaf, demonstrate the steady development from a primitive and often unconfident letter to the penultimate – in some ways the finest because more searching – stage, before the letter became set in its final form. All six examples are from either Bury or Rochdale – Lancashire towns about eight miles apart. (68) from Bury is a rather uncertain letter, although quite regularly cut. As one might expect from the region, it is straightforward with no particular idiosyncrasies – unlike early West Country stones – and shows some attempt to regularise the form: compare the shape of the a and d which have, usually, a similar kind of curve.

The carver of (69) from Rochdale has allowed himself the luxury of a few flourishes, but he has also created a richer form by carving more positive serifs, and used thick and thin strokes more assuredly. Many letters appear to be a refined version of those in (68); I wonder if it was the same carver. Compare the r, w, and d.

The inscriptions in (70) from Rochdale have been cut on three different occasions spread over sixteen years, but there is little change between them. Yet again, as in (68), we see the English R. The forms are still uncertain; but serifs are yet more pronounced, the cutting is deeper giving bolder strokes, and it seems to me to show the clear beginnings of the english letter. This is more appparent in (71) from the same town, and probably by the same

carver – compare the e, S and a. If the same man, he has learnt a lot in eighteen years. The english letter is, in all essentials, here fully formed.

(72) from Bury shows it being refined, and being cut with increased skill. The intractable regional stone has no doubt helped to create a rather severe letterform, discouraging swirls and flourishes, although local tastes probably also leaned this way; but the carver has been able to demonstrate his increased confidence by his handling of curves, which now have a spring and life previously lacking.

In none of these stones has there been any influence of outside trades or sources. Only with the final example in this sequence, (73) from Rochdale, is there any possibility of copybook influence (in the decorative heading), and this is far

from certain. The rest of the inscription shows increased confidence in the handling of the form, the cutting, and the overall design, incorporating a few italic words for liveliness. Unusually extended serifs add an original touch.

The cutting of all these stones would originally have been sharper; not only has weathering affected them, but – like so many stones in the north – they have been laid flat to form pavements. Even this hard stone will survive only just so much of such treatment.

The 1790s appear to be the crucial period hereabouts, when the development of the english letter was at its liveliest. It was to undergo a few changes yet before settling down to a fairly unvarying form, often pleasingly cut and used. It never seemed to become a formula.

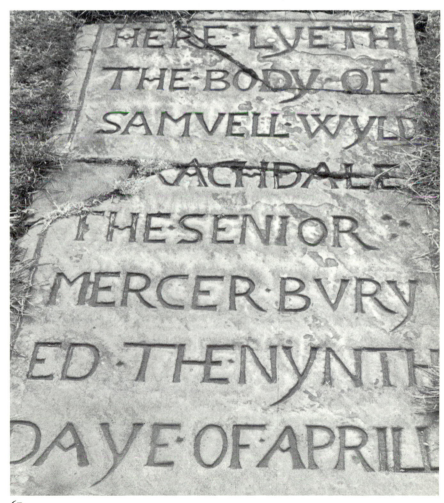

67

Here Lyeth the Body of
Richard Barlow of Bury :
Mason who dyed the :5.th of
August and was Interred the :
:7.th Anno Domini .1684.

68

Here Lyes the Body of Alice
the wife of Thomas Collier
who was Buried y̓ 1.st day of
May Anno Domini 1706

69

Here Resteth the body of John
Leach the Son of Abraham
Leach who departed this life
y̓ 10.th day of Novmber 1725
Also Hannah his daughter who
departed March 11.th 1728 aged
16 Months Also Martho his Daughter
he dyed the 6.th of June 1741 Aged 4en

70

Here was interr'd the Body
of Joseph the Son of Joseph
Allen who departed this Life
Decem.r 6.th 1759 in the 8 Year
of his age.

71

parted this Life April 24.th
1792, aged 8 Months.
Also the abovesaid Henry
Hindle who departed this
Life the 11.th Day of Sept.r

72

HERE

was interr'd the Body of
Nicodemus Clegg Innkeeper
of Blackwaterstreet Rochdale
who departed this Life the
19.th day of August 1797 in
the 45.rd Year of his Age.

73

I do not wish to be drawn into inter-county arguments, and that the previous sequence was from Lancashire, while this next sequence is from Yorkshire, is of no especial significance. Nonetheless, there is a distinctly different feeling between the two, although this may merely be the fortuitous result of my particular selection.

The first three are from Todmorden – as far from Rochdale as Rochdale is from Bury: that is, eight miles. And it must be said that not only is the form different, it is better than the Lancashire examples of this period. (74) is an italic almost certainly derived from copybook specimens: delicate and beautiful letters, confidently and freely cut – unusually so, for this date. (75) is the bottom half of the same stone. It has a similar delicacy and assurance, but stands on its own, independent of copybooks. It relates well to the italic above, rather like the roman and italic of a type family, but it has several quite personal features, not least the treatment of serifs.

Ten years later, the same man (if the decorative initials are anything to go by) was cutting a very different and perhaps yet more skilful inscription (76). The form has been somewhat condensed and the serifs cut more subtly, but it retains the pleasing freedom of treatment, particularly evidenced by the near-flourishes of the y and f. The rounded letters have been consistently handled.

(77) is from Hebden Bridge – only five miles away – but has many different characteristics while remaining firmly within the style of the english letter. The unusual drawn-out t, curly top to the f, and other decorative touches, give it a charm which more than makes up for a slight lack of skill or regularity in the cutting.

At Bedale, way across the Pennines, (78) shows the lettercutters' skills perfected. The lettering on this stone is as accomplished as any on the South Midlands stones, although its form is rather different. Like most West Country designs, the gradation is less abrupt, giving a rounder, less vertical effect. Delicate thin strokes; delicate, horizontal, and often only slightly bracketted serifs; full curves emphasised by the terminations of e and c carried well up; strange little flicks to the serifs on the C and s: this is a fine and assured version of the english letter, lighter in weight than usual.

74

75

76

77

78

A bolder form is more characteristic of the north, and these two from Halifax (79, 80), as well as (81) from Keighley, show the english letter in the ultimate form of this region, and at its very best.

The Halifax pair have been given unusually decorative headings or names; both are clearly derived from copybooks. These are *tours de force* in intractable stone, beautifully controlled technically and aesthetically. The smaller lettering is equally masterly, with its variations on upright, italic, and capital forms. Here is a toughness we do not find in equally disciplined cutting in the South Midlands.

79

80

The example from Keighley (81) is our final Yorkshire stone. Strongly cut thicks, with fine thins and fine slightly bracketted serifs; confident forms; advantage taken of letters such as g, f, r, and the numerals, for small, controlled, enlivening details; all this is executed with assurance. The few decorative initials and what-not may have come, some way removed, from copybooks; but the whole is essentially a carved creation, owing little or nothing to any other craft.

This applies also to (82) from Porlock, Somerset, a West Country stone shown here for comparison. If we ignore the personal touches to the serifs and the slightly more self-consciously shaped terminations to the e, the two are remarkably similar. The Keighley letter is merely a little less wilful, more stern and unbending; a northern characteristic – or so northerners like to tell us.

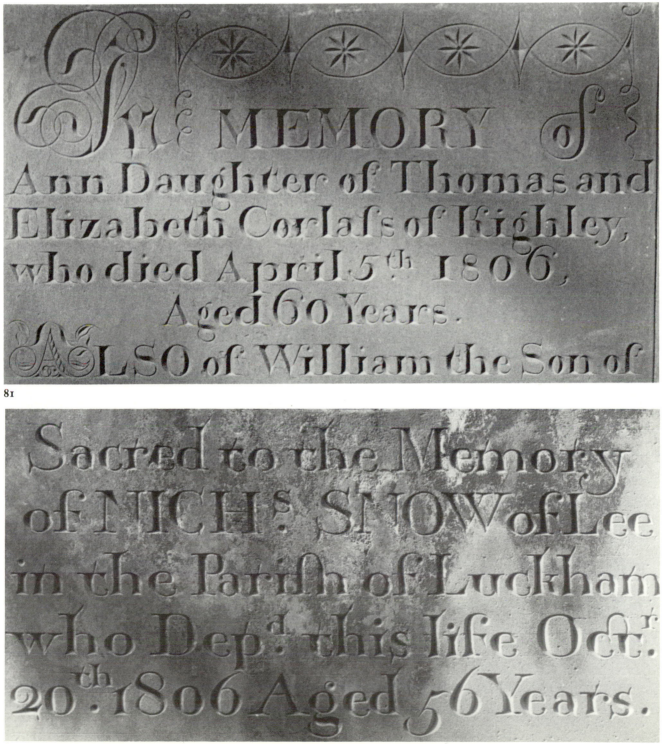

81

82

So we come to Cumberland, which confounds us all. Although I wonder if it should. The mountains are higher and rockier and steeper, but there is little in the region as austere, as wutheringly bleak, as Pennine moorland. And maybe it is a true reflection of the land, and of the perhaps slightly dreamier people, with their softer accent, that Cumberland tombstones are often carved with more decorative devices, or softening touches, than most of those we have seen since the South Midlands. That the stone is slate has helped; but so are many of the Cornish stones, and even when using a riot of types the West Country cutters did not achieve the same warmth.

The earlier stones in the region appear to be influenced by the copybooks: (83) from Cockermouth shows a form which, although in places a script, has mostly unlinked letters. It is nowhere a direct copy of writing masters' forms, for it has gone through the carving process and is essentially a carved letter. It is far from unskilled, and the frequent swashes or flourishes are well-controlled.

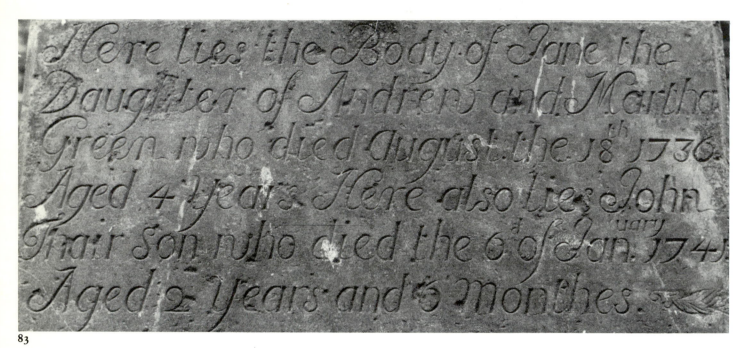

83

84

For comparison I show a South Midlands letter: (84) from Loughborough. This is in itself an oddity, appearing to be half-way between the Belvoir letter and the sharper form more prevalent in the region. It appears to have been cut in 1717 – rather early. Clearly influenced by copybooks throughout, it is not so very different from the Belvoir letter in (39); although its more delicate weight relates it to the rival form also. But what interests us at present is its relationship to the Cockermouth design. More skilfully cut, rather sharper contrast between thicks and thins, a more confident use of flourishes; but not *that* different, overall. Even the calligraphic form of w appears in both.

From the evidence of stones such as these, I am tempted to suggest that if the Belvoir form had not been aborted, it might have developed in much the same way as the Cumberland lettering. (85) from Brigham has strokes of consistent weight throughout, unlike the Belvoir letters or even the Cockermouth stone, but

this is merely different flesh on similar bones. The Brigham stone has its own funny little personal touches such as the e and s: an almost West Country delight in curling the ends. But so were the Belvoir men keen on similar enlivening devices.

It is, unusually for this date, virtually unseriffed. These are beginning to appear on the letters in (86) from Great Crosthwaite. We are moving still further away from copybook influence, with now, as in

(85), no suggestion of scripts. The letters merely retain the slope of that form, and vestigial reminders of script origins in extended descenders and flourished capitals: like the Cockermouth example the letters show little difference between strokes normally thick and thin. But, nonetheless, we have nearly arrived at the upright minuscule.

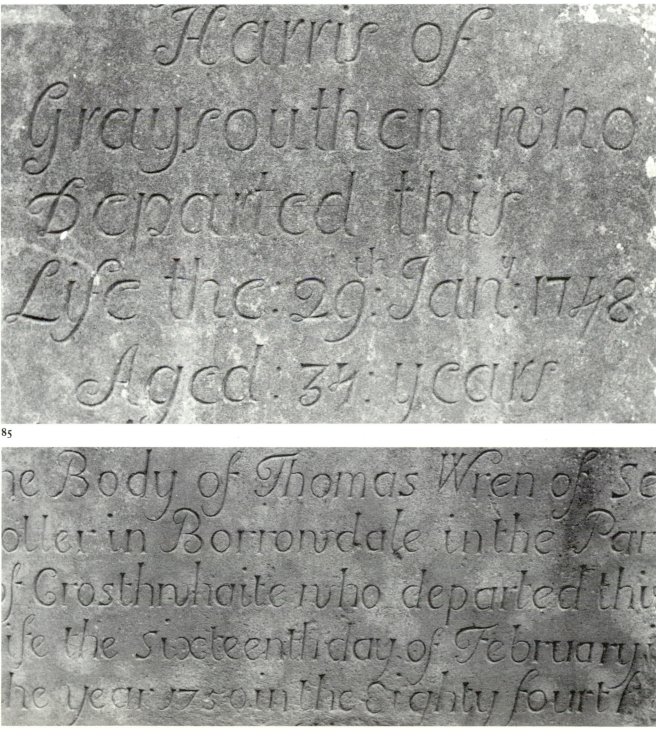

85

86

With (87) from Wigton, we are there. Judging from the standard of design and cutting seen here, it had already been well-established by this date. Delicate and sensitive, it is different in feeling from South Midlands, West Country, and other northern forms, being less vertical in character than the first, more regular and skilled than the second, and softer than the third. Rather like a developed Belvoir letter, perhaps. It most nearly approaches the Bedale letter of (78), but its angled serifs give it a more relaxed look, as does the softer gradation from thicks to thins, most noticeable in the round letters but which also emphasises the curves in letters like m, n, h. A stone of 1789 at Great Crosthwaite is almost certainly by the same carver.

The climax of the development in Cumberland is typified by (88) from Great Crosthwaite. It is all here: the confidently-cut english letter with strong slightly bracketted serifs, good contrast between thicks and thins, and straightforward no-nonsense forms, apart from the oddly abbreviated g. As for the overall design, frequent mixings of italic, black letter, words or lines in capitals, even a script, and even a backward-slanting letter; the occasional careful flourish; small superior letters used when abbreviating words – all these characteristic Cumberland devices result in a warm and rich overall texture. The italic letters are particularly pleasing. Pevsner states that this stone is locally attributed to William Bromley. I have seen stones which must be his work at Cockermouth, thirteen miles to the west, and at Threlkeld, three miles to the east. See, also, (5), (106) and (340).

This classic Cumberland example may be compared with the South Midlands classic of (50). Two nations, north and south.

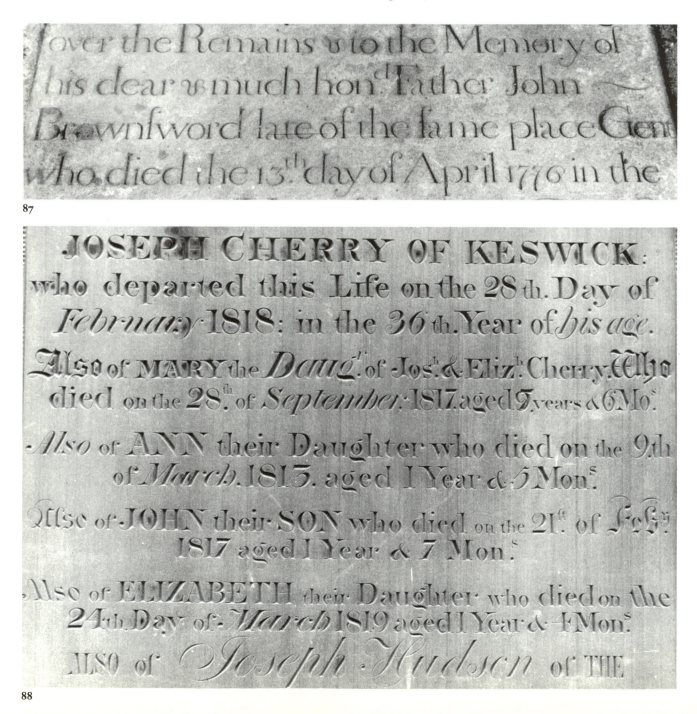

87

88

The regions I have covered do not exhaust the variations of english letter to be found around the country's churchyards. Tiny churchyards in some of Cumbria's remoter dales often secrete a worthwhile example or two. However, my regions, probably almost entirely due to the local stone, have developed an especially fine tradition which, also because of the nature of the stone, can still be seen in some detail. So often, wandering around a churchyard, one is disappointed either in the unvarying and indifferent letterforms, or in the ruinous state of the stone – or both. But many churchyards, outside my regions, do contain one or two good isolated specimens: erratics, like boulders left by a melted glacier.

Kirkby Lonsdale (89), although in Cumbria, is on the border of that county and Lancashire. The lettering of this stone of 1801 is not quite like that in either of our sequences from those counties. (This part of Cumbria was Westmorland anyway.) Although clearly an english letter, it exhibits the kind of personal variation one is likely to find anywhere in the country. A so-called regional style is often, in reality, the style of one or two men. The particular mannerism here is the termination of the vertical strokes with a kind of double serif. Consistently and well cut throughout, it lacks the brilliance of the best lettering of this period. Lettering is in many ways a subtle craft, and quite why these letterforms are less satisfying than, say, those in (88) is difficult to explain. They are, though.

The same applies to two Welsh stones. I had expected to find many good examples in Wales, a land of so much slate. Perhaps I have been unlucky in my choice of churchyards. Many stones can be found with the standard of lettering shown in (90) and (91), where there is much to admire. But, compared with those we have seen from other regions, these are a little hard. (90) from Dolgellau, Gwynedd, is not far removed in form from (80), yet it is noticeably less pleasing. The curves lack the generous feeling and tension of the Yorkshire stones, where the fine thins spring from the verticals of d, h, n, and p: he who cut the flourishes in (79) or (80) really knew about curves. Those around the heading of the Dolgellau stone are weary in comparison.

Much the same criticism applies to (91) from Ffestiniog, although here the slightly finer thins benefit the letter. These two Welsh stones have very similar forms: the back-to-front serif on some ds for instance is common to both The towns are about sixteen miles apart. The slate could well come from nearby Blaenau Ffestiniog in both cases; and, if the slate, perhaps the carving too. It is instructive to compare these two stones. Both the upright letters and the italic in (91) are more lively. If it was the same carver, he improved. He gained the vital extra degree of freedom in his cutting.

89

90

91

68

I have been able to show broad regional trends by being selective in my examples. The true picture is not so simple or so consistent, although I believe my picture is correct in overall spirit. On this spread however I show some misfits.

92

93

94

(92), with its bold condensed form, is reminiscent of Belvoir lettering, although less confidently cut. It comes from Bridestowe, Devon. Its strong verticals create a pleasing rhythm broken only occasionally by a few awkward letters. The g in particular gave the carver problems.

I would not expect to find such a wealth of flourishes and curlicues anywhere in the north, but (93) is from Todmorden, Yorkshire. Much less disciplined than Cumberland stones, it is, dare one say it, a bit of a mess. But its basic form is good, and its high spirits are appealing.

More sober, and not such a surprise, is (94) which also comes from Todmorden. But this stone of 1741 has characteristics one might expect to find in Belvoir, although there stronger serifs were favoured. The decorative A is very close to that in (75). Might this be the same carver? A comparison of (75), (76) and (94) could be an illustration of one man's development over thirty-four years.

(95) and (96) are tiny glimpses of a large and infuriating stone at St Ive, Cornwall (near Liskeard), almost entirely covered by another very heavy (and far inferior) slab which is impossible for one person to remove. These amazing letters from the edge of the stone would look more at home in the South Midlands, although the bracketted serifs and the form of the d do not belong there. I have not seen such skilled cutting of this date elsewhere in the West Country. The decorative initials are, of course, straight from a copybook.

If anyone is tempted to see the rest of the stone, take two strong men.

Finally: who would guess this stone (97) comes from Bottesford, Leicestershire? It could almost come from Cumberland. However, the letters are, on closer inspection, a bold form of the South Midlands design: a little less rich and with taller ascenders than northern forms, but without the stale and lifeless feeling of most South Midlands cutting at this time. The simple, restrained, but far from cold design – of unusual quality and sensitivity for the date – is again more characteristic of Cumberland, where a few more carefully controlled flourishes might have been incorporated. Even the swash around the truncated stems of the D and R can be found there.

These pages of tombstones have shown the progress of the english letter from its diverse beginnings to a coherent mature form. From now on, variations on the english theme are best illustrated from other sources. I have deliberately shuffled the chronology around, to demonstrate how consistent the form remains.

95

96

97

We step through the looking glass. Our image of widely spread roots growing into a sturdy trunk reverses: the trunk grows leafy branches. Different regional letterforms have converged to create the english letter. Now this is to be used throughout the country, a single form but with many variations, adaptable for different materials, techniques, and uses.

The basic form is shown to perfection in a street name from Bath (**98**). Symbolically, one might say, this is a recent recutting of an eighteenth-century form:

certain changes have no doubt been made to satisfy twentieth-century mores, but it belongs happily to both centuries.

Bath abounds in such well-cut names, almost all slightly different in form even when within a generally similar style. The originals were probably cut in the eighteenth century, not necessarily when the buildings were put up; but many have been recut in recent years – about this, more later. Perfectly disciplined, deeply cut, this example has a freedom bred from mastery of technique and form.

98

99

100

101

102

Making allowances for the change of medium, (99) is not so different. It is from a Pullman carriage of 1913 (now at York Railway Museum). The painted shadow effects seem, as so often in the vernacular tradition, merely to enrich the appearance rather than attempt to create a convincing three-dimensional design.

In the hotel sign at Milford Haven, Dyfed (100), the incised letters are not V-section as in (98) but square-section – possibly achieved by positioning wood moulds in the area to be plastered, and

withdrawing them when set. What these letters lack in classical purity, they gain in richness and vigour. The R in (98) and here are two versions of the characteristic english R.

Robust gilded letters adorn an early nineteenth-century shop front at Kendal, Cumbria (101). Generous serifs seem to look forward to twentieth-century trends, as exemplified by (102) from Tralee, Co. Kerry.

The three pieces of lettering from an LNER carriage of 1934 (103, 104, 105) now

at York Railway Museum, show a fine basic form on the face of the letters, closely related to the five previous examples, with the intricacies of shadow effects that these railway signwriters lovingly elaborated upon. Again, true three-dimensional illusion does not seem to be the aim. The lettering – whether painted or in cast metal – used by all the railway companies, from their inception until the Second World War, has never been surpassed in inventiveness, execution, or fitness for purpose and situation.

103

104

105

The italic form of the english letter was as widespread as the upright, and its lineage is equally consistent. A tombstone at Great Crosthwaite, Cumbria (**106**) shows a carved example, probably of about 1820; it is effectively the roman, sloped. (**107**) and (**108**) are gilt-painted letters from a long-surviving shopfront in Soho, London, and although differing in detail from the previous cut letter, they are within the same tradition. There are two forms of A, that in (**108**) more nearly resembling those in (**106**).

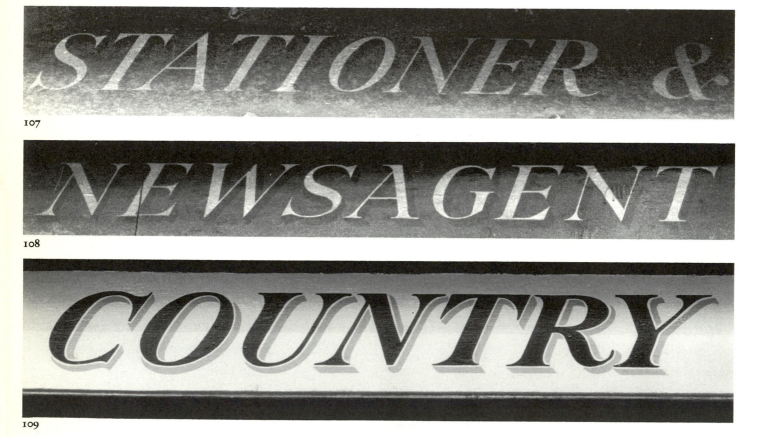

106

107

108

109

The modern example from Dunster, Somerset (**109**), although bolder, is otherwise almost identical.

(**110**) and (**111**) are two more street names from Bath. A dozen were recut, like (98), about 1955 by Peter Watts. Many more were done about 1953, when the bombed buildings were being restored, by fourteen or so schoolchildren (girls and boys aged 14 or 15) directed by Theo Olive. Although he himself cut 'Belmont', its unusual triangular serifs were originally evolved because several children would work on the same name – sometimes the same letter – and had difficulty in cutting matching curves. 'Green Street' employs a different traditional form.

This exercise was an opportunity to test Mr Olive's theory that a basic understanding of letterforms, plus a sympathy with materials, function, and place, are more important than technical skill. Not only has it proved the theory, but it has demonstrated that there is little excuse for poor lettering in our environment. Would a future lettering historian guess that these beautiful names had been cut by schoolchildren, one afternoon a week, during a summer term?

Still within the tradition, although it could be the work of an 'artist craftsman', a sensitive and well-cut letter at Winchcombe, Gloucestershire (**112**) is as suited to its purpose as the Bath street names.

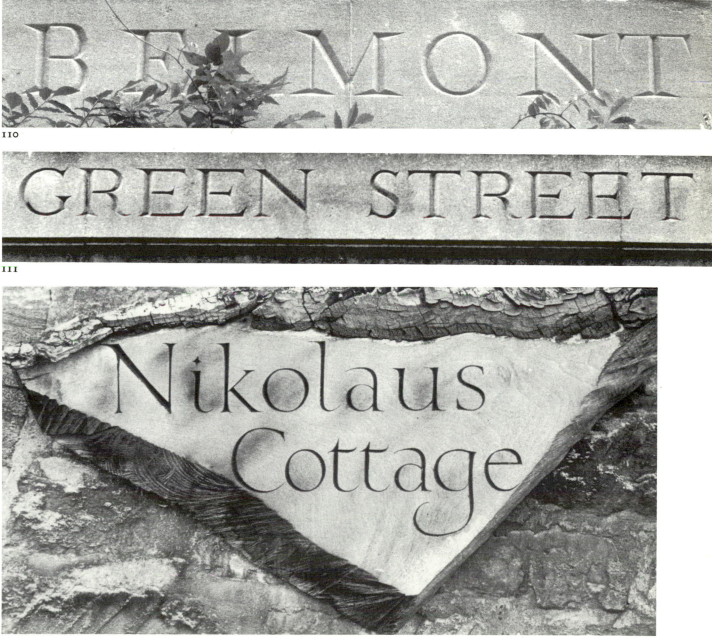

110

111

112

The story of the vernacular tradition is not without surprises. Three examples of cast-metal lettering, two of them on the heavy engineering of the early nineteenth century, are considerably more bookish in form than those we have been looking at. (113) is from Witney, Oxfordshire, and the moulds might almost have been derived from a type by Baskerville. Only the r is at all awkward, although the u has an unusual double serif. The d is pure Baskerville.

The lettering on the atmospheric engine in the Science Museum, London (114) is also similar to printing types, especially the numerals; that on Trevithick's steam engine of 1803–8 (115) at the same museum, is not far removed.

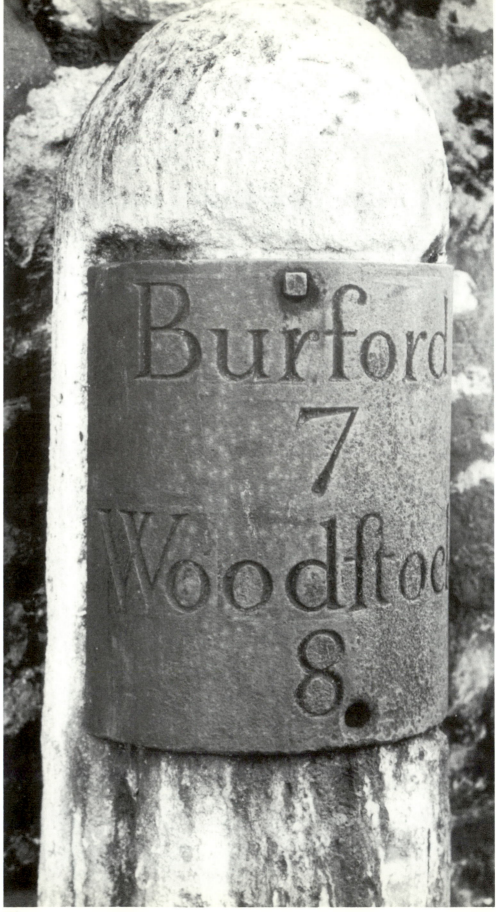

113

114

115

More characteristic of engineering, the forms here progress towards the clarendons we shall see later. *The Agenoria* (**116**) is on the driving-wheel of a locomotive (now at York) from Shutt End railway. Its delicate forms hardly withstood the casting process, although they look pretty enough painted up. They can be seen as precursors to the far more satisfactory letters at Bridgnorth, Shropshire (**117**), one of countless similar styles found around the country. Street names

116

117

throughout this town are in this cast-iron letter form. Bridgnorth is about eight miles from Coalbrookdale, where the first coke-smelted iron was poured in 1709; although this lettering is probably from the first half of the nineteenth century.

A stronger form was used on *Locomotion* (118) of 1825, now at Darlington Railway Museum. It is almost a clarendon, although the serifs are quite light. Very similar is *Derwent* (119) of 1845, also at Darlington and which also was used on the Stockton & Darlington Railway. Right from the beginning of the railway era, these appropriate brass plates carried the locomotives' names.

In the nineteenth century, a wide range of architectural letters was available, and (120) from Great Malvern (Hereford & Worcester) shows one, closely similar to those on the locomotives. These are probably of plaster, and have fuller serifs than the metal letters. The letter- and word-spacing is unusually tight: too tight.

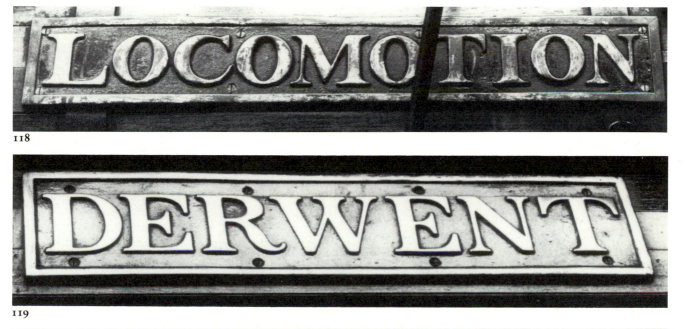

118

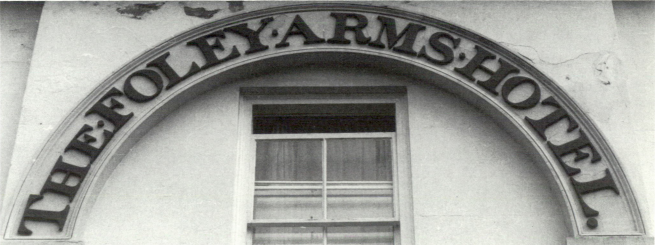

119

120

121

122

Some unusual small features can be seen in (**121**) from Sudbury, Suffolk. Smaller in scale than the previous example, it lacks its almost Baroque extravagance, and is not of stock letters. Too fine to have been cut in relief, it was probably cast. Although it verges on a clarendon, it has some unusual and delicate details, such as small decorative touches on the H and G. The later, upper inscription lacks these and is altogether less refined.

The lettering in (**122**) from Barnard Castle, Durham, looks in good condition for the date. If it has been repainted, we cannot be sure it faithfully follows the original, but it is a good sturdy form with occasional personal touches like the serif on the h. The use of minuscule letters is not common on such inscriptions.

The english letter was, and is, used for everything. (**123**) is a milestone on the A483 in Powis. The carver's limited skill has been sorely tried by having to fit the letters into a semi-circle, but the overall effect is pleasing and legible.

(**124**) on the church wall at Egloshayle, Cornwall, is obviously the work of a tombstone carver, who deemed no change in form necessary or desirable.

123

124

The *grateful* Inhabitants
To GEORGE THE THIRD
On His entering the 50th Year
Of His REIGN.

125

to the Memory of
Thomas Buttery,
who departed this Life
September 9th 1838;

126

The County Outfitters

127

While the sharp South Midlands form died a cold and lingering death in the region, the style can be found elsewhere, particularly after it had been given new life by a transfusion of the typeform known as modern. A similar letter, although slightly expanded, can be seen at Weymouth, Dorset (125). It dates from 1810, and shows no direct influence of either the South Midlands form, or type; it is an english letter with horizontal unbracketted serifs, and a sharp gradation from thicks to thins. These details give it a somewhat wiry look.

A late appearance of the South Midlands form at Newark, Nottinghamshire (126), closely resembles types by Didot and Bodoni, and is itself almost identically repeated on a shop at Winchcombe, Gloucestershire (127). This simple fascia, tasteful and discreet, says a lot; nothing vulgar here: good hardwearing tweeds, and don't expect anything else. And after all, creating a good letterform is only half the problem: it must also be right for its situation and purpose.

By these criteria, the metal street name at Birr, Co. Offaly (128) barely passes muster. It is a pleasing form, but small for its position and delicate for its technique – though it has been well cast in unexpectedly deep relief. Forms like this are rarely found as cast letters – hairline thins and serifs are a challenge for the process. Although throughout the vernacular tradition such challenges rarely prevented the use of an inappropriate technique if the craftsman was determined to use it.

In a type book you will find the style used at Abingdon, Oxfordshire (129) called a modern. I do not agree with such terminology, and I place this firmly in the tradition of the english letter, with its rich forms and generous curves; although the influence of the modern typeform is apparent in the strong contrast between thicks and thins.

What really gave new vigour to the sharp-cut style which we saw developing in the South Midlands but which gained its final form, and wider currency, quite independently, in the typefaces of Didot and Bodoni, was the Victorian fattening-up of the thicks, like some Christmas turkey, into the form known appropriately as fat-face. Two similar versions are shown here: a wood form (130) from

Llandovery, Dyfed, and the brass-cast *Greenore* (131), an ex-LNWR, becoming LMS, locomotive now at York. Neither are especially good, looking, for all their weight, stilted and mean. The Welsh example is the better of the two; *Greenore's* serifs are too stubby. The form is seen at its best not in vernacular use, but in print, in for instance Victorian playbills.

128

129

130

131

132

133

Strictly speaking, these fat-face letters do not belong in this chapter called *Eighteenth Century Elegance,* dealing with the english letter. But their derivation is more nearly from that letter than from any other in this book, even though they were developed in industrial Britain. Moreover, they may be less out-of-place than first appears, for there is no reason to believe that the inscription in (132) at Tamworth, Staffordshire, was not put up at the time of the building – 1701; and while these letters almost entirely resemble a fat-face, some slight bracketting suggests they are actually a very bold english letter. They have the vigour of fat-face types of a hundred and twenty years later.

There is a hint of bracketting, too, in the enamelled tile letters at Warwick (133), but the form is less rich. It could almost be French. The intrinsic design of the gilded letters in (134) from Bond Street, London, is more subtle than that of (131) which it closely resembles; but the skewed three-dimensional treatment – a frequently-used Victorian trick – gives it additional substance and interest. If these are not genuine nineteenth-century stock letters, they are a very convincing imitation.

Although the later West Country carvers depended upon type specimens for much of their decorative work, they would sometimes interpret these freely, not to say wilfully. At Egloshayle, Cornwall (135) this stone of 1854 uses an italic fat-face where the bold strokes are V-cut, with the remainder – thins, or the outline of the 'shadow' – lightly incised. The three-dimensional thinking here is a little confused.

A thorough-going fat-face is seen cast at Clonmel, Co. Tipperary (136). So fat that counters begin to disappear – putting effect before legibility – it demonstrates what is missed in (131) by half-heartedness.

134

135

136

Of these five condensed variations on what is still basically the english letter, only (137) from Wigton, Cumbria, has any claims to elegance. Its pleasing rhythmic form is quite freely painted. The Os are perhaps not entirely satisfactory, but it is a typically unpretentious and competent piece of work by a local signwriter. (138) from near Holsworthy, Devon, and (139) from Narberth, Dyfed, are more awkward, but adequate for their purpose. (139) shows some ambition in the treatment of the shadows, although the straight-legged Rs are rather stiff. I feel the signwriter's intentions outran his skill.

But a well-executed revival of an old tradition on the long-boat (140) takes its place happily among the painted roses. A few simple touches – extending the leg of the R for example, or cross-bar of A and H – have here greatly increased the decorative value.

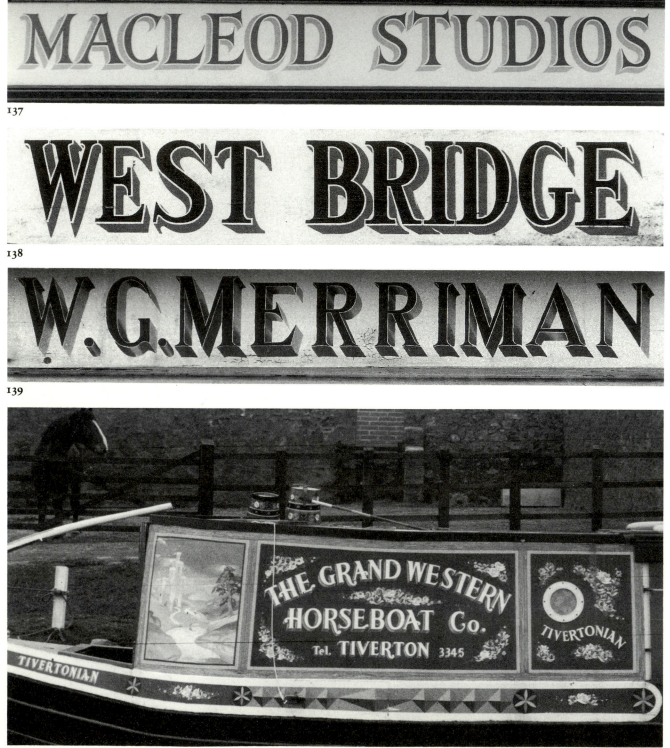

137

138

139

140

The ceramic letters of (141) at Stoke
Newington, London, are a little debased,
but the technique, affecting the form to
give the letters a slightly concave face,
and slight irregularity, produces an indi-
vidual character.

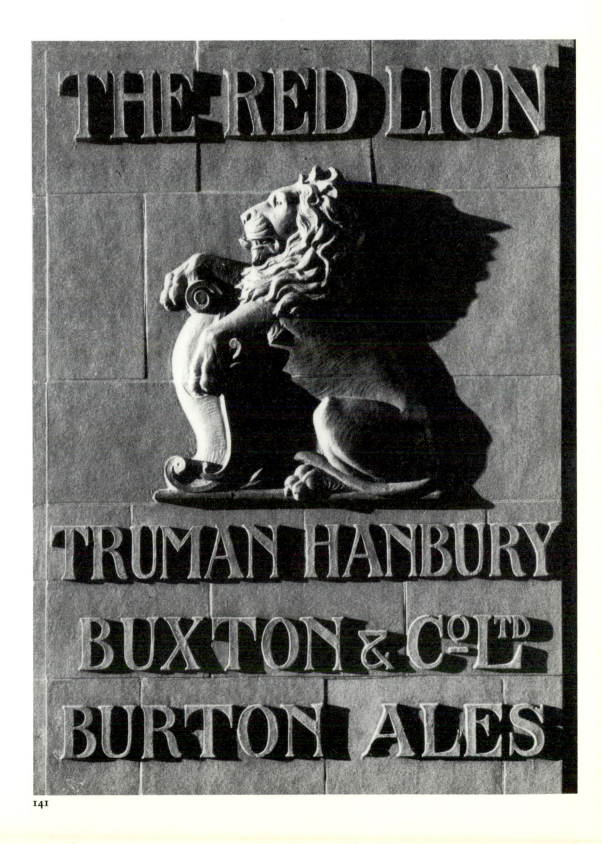

86 We have been gradually moving away
from the classic form of english letter.
Here are some personal interpretations,
all of which are, loosely, versions of it.
None are conscious attempts to conform
to any style, but are merely pieces of let-
tering produced to do a job. Some may
not even have been done by signwriters.

142

143

144

145

A sensitive form from West Linton, Borders (142) is somewhat hesitant in execution; the lower half of the S has gone astray. Somewhat bolder is (143) from Ulverston, Cumbria, where again, despite a narrow N and a wide E, the felicities outweigh the deficiencies. Neither of these should be judged by the standards created by type designers. They are humble pieces of lettering perfectly suited to their situation in village or small country town. A more proficient example from Market Drayton, Shropshire (144) befits its situation. Well-coordinated and worked-out, owing nothing to any source such as typeforms, it is part of the continuing tradition, carried out by a signwriter who knows his job. A small piece at Gayle, Wensleydale (145) however could well have been done by a knowledgeable owner. Prettily and sensitively painted in blue on an uneven and difficult surface – direct on the stone wall – it has the freedom and freshness born of a thorough understanding of letterforms.

I have fewer guest-house or bed-and-breakfast notices than their surprisingly high standard deserves. Here is one at Cartmel, Cumbria (146) with a lot of individuality, if a little amateurish. A similar weight of letter is used in (147) from Hawkhurst, Kent, but this is thoroughly professional, sensitively painted, with delicate and controlled serifs. Both pieces fit their situation; as does (148) at Grassington, Yorkshire, a too rare example of wood-carved letters. The sturdy and individual design is the natural outcome of using this in some ways difficult material in relief.

Like (145), the expressive warning sign at Dunbar, East Lothian (149) could well have been done by the owner; but what a different approach! The fortuitous but nonetheless alarming teeth on the gate are a bonus. The notice is probably all the more effective for being somewhat unskilled, although a sophisticated shadow treatment is attempted: poor relation of the railway lettering.

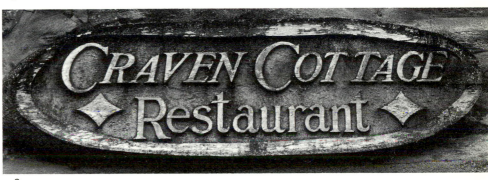

146

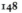

147

148

149

The signs and fascias of some towns are dominated by the work of one signwriter. Such a town is Ulverston, Cumbria. There is much that can be criticised about the work shown here, but it contains the very essence of the English tradition as currently practiced.

The first example (150) is actually from nearby Dalton-in-Furness, but is obviously by the same man. The exaggerated difference between fine thins and rather bold thicks terminating in strong and almost triangular serifs, is characteristic. An almost identical form (151) in Ulverston itself differs mainly in tighter letterspacing and the tonal inversion of letter face and shadow. This is only one of countless small variations played upon the basic form: (152) is another. The straight line through the S, although consistent, is awkward.

(153) was photographed in 1976, and (154) in 1982. Is this second one the work of an apprentice? The letters are painted with more freedom, but coarser thins and less positively painted serifs result in a loss of taughtness. The forms of the C and A have changed; the decorated version in (152) uses the old form of C but the new form of A. The painted shadow is now weaker and less precisely related to the

150

151

152

153

154

letter face. Despite its stiffness, the earlier version was more personal.

A better example of the same basic form is seen in (155) from Tewkesbury, Gloucestershire. The serifs are more sensitive and the curves less awkward.

The sign at Huntley, Grampian (156) shows especially well the freedom with which a skilled signwriter can use his brush. There is an almost sensual lus-

ciousness of paint. A juicily-full brush has been used to create thick bold strokes, but a seemingly casual flick terminates the shadows. It has something in common with (154) but has been done with more dash. This is not Victorian vernacular; it is the vernacular of the last quarter of the twentieth century.

The same current tradition is thriving in a rather unexpected situation: the cab-

doors of heavy lorries, especially livestock trucks, although (157) happens to be a fish carrier. Well painted in splendid colour schemes, they are proudly kept. They are today's equivalents of railway lettering, interpreting the same basic repertoire – particularly the elaborate shadow forms – in their own way.

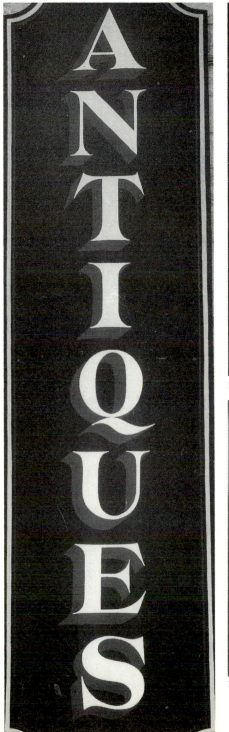

155

156

157

It is difficult to judge the age of painted lettering, but my guess is that this example from Girvan, Strathclyde (158) is about thirty years old. Although more informal, it has much in common with the cab-door lettering, in particular the treat-ment of the shadows and returns of the letters. The Scottish example here (159) has unusual linear 'highlights' in places where no true highlight would ever be found; done to enliven the design rather than create visual truth. Two others (160) and (161) were both photographed at Hexham, Northumberland – these lorries travel far – but they show a similar desire for effect. An elaboration of treatment beyond normal expectation demonstrates the enthusiasm that has gone into this

158

159

lettering. Although hardly apparent in the photograph, the words 'Hallikeld House Brompton' have painted returns, like the rest. The shadow and highlight effects create a graphic pattern – as in railway lettering.

160

161

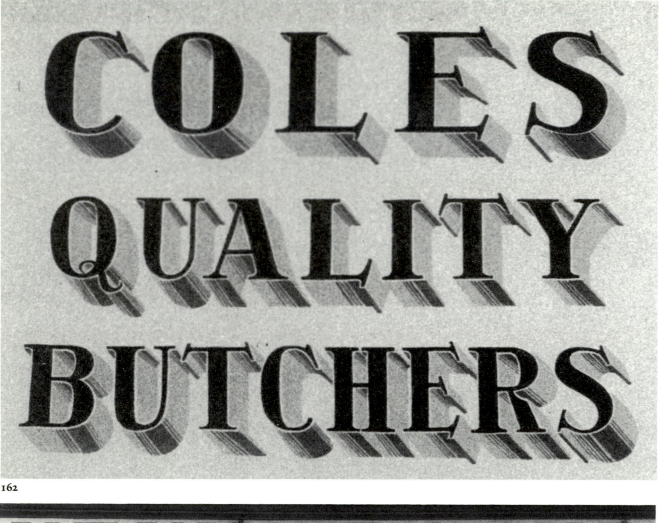

162

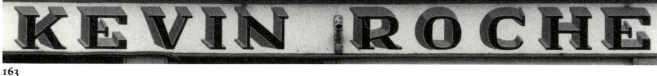

163

164

3. The formal made informal

A similar interest in devising pattern out of shadow effects is seen at Budleigh Salterton, Devon (162). An unskilled and uneven form, the striped shadows create a character which disguises the awkward shapes.

Some personal and characterful forms are being done in the Republic of Ireland, and Wexford has some particularly choice specimens. I don't think anything like them could be found outside the British Isles, and probably not outside Ireland, although they seem to me to be merely extreme manifestations of the English tradition rather than a new departure. Strange fierce perspective and forms resembling steel girders are used in (163), while (164) – where the serifs are of more truly english form – has organic terminations suggestive of leaves sprouting out from branches. The imagination shown here must result from a love the craft.

a. Pen-derived scripts

Scripts developed along two streams. The more formal, closely linked with the work of the writing masters, derived its appearance from the pen. The informal script derived its appearance from the brush.

These two instruments, used with directness and fluency, produce forms of a different character. The pen itself can produce different kinds of marks, depending upon the way the nib is cut, the degree of its flexibility, and the way it is held; but the way with which we are concerned exploits the flexibility of a pointed, not a chisel-ended, nib, and is used in a manner which produces bold strokes on its downward path, and very fine lines on its upward. This characteristic can be easily reproduced by the engraver's burin (when engraving the copper plates from which the writing masters' books were printed), and can be equally easily reproduced by the stone carver's chisel – especially if he is working in slate, as the South Midlands carvers were.

Later, for other larger-scale uses such as shop fascias, the brush would be used to recreate these forms; these were built-up letters, not the direct result of the tool. Even more elaborate methods were used – carving into a flat sheet of wood, creating a V-section or U-section in so doing, or carving free-standing letters out of wood. In none of these was the form related to the original technique – it was a complete recreation, greatly enlarged and richly three-dimensional, of the pen form. Such techniques could produce splendid results.

The early scripts to be seen on tombstones were somewhat clumsy, a sort of rustic handwriting. They soon became more sophisticated, with increasingly elaborate scrolls. These (and the letterforms) were obviously influenced by the writing masters, but they also seem to be a direct expression of exuberance on the part of the carver.

Like the english letter, the script – a kind of cousin – allows many interpretations on its basic form. Again like the english, it is still being freshly interpreted today. While its strict regularity is sometimes ignored, the resulting freedom gives the lettering a lively vigour. The original pen-created form is also sometimes lost, to be replaced by equally interesting if less elegant shapes. The signwriter (for these forms are usually painted) is thinking, not mindlessly and mechanically reproducing.

Many of the devices and conceits of the writing masters were taken over by the tombstone cutters, but rarely are so many incorporated into the same design as at Callington, Cornwall (**165**). The sources for all these goings-on would have been the copybooks of up to fifty years earlier – the writing masters themselves had, by 1730, moved on to more regularised forms: 'copperplate' as now generally understood. The features of this stone:

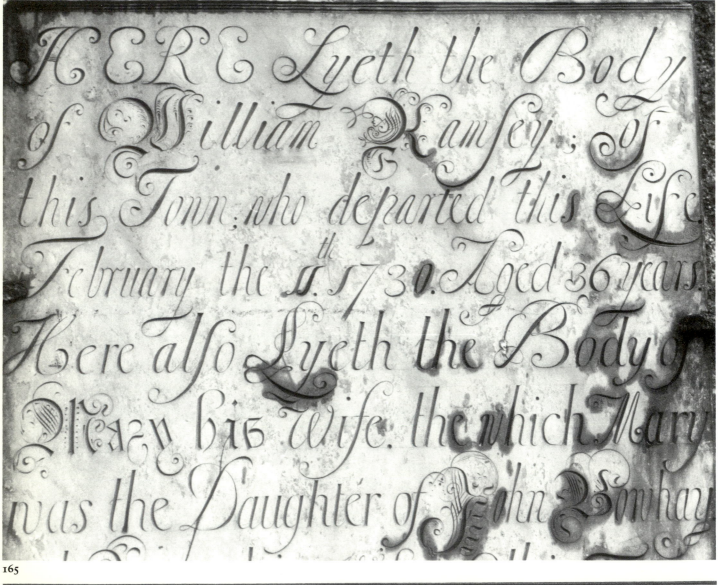

165

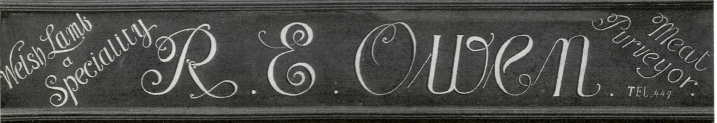

166

the almost illegible initials – created to demonstrate prowess with the pen; other capitals with their drunken scrolls and flourishes; the embellishments on the minuscules; the very form of the thickening (or thinning) down strokes; all these come direct from late seventeenth-century copybooks, if a little casually interpreted. This carefree, almost haphazard, lettering was probably cut – by the same man – in two stages, the top four lines six years before the rest. Any theoretical lack of unity seems irrelevant when face-to-face with the stone: one is only aware of the carver enjoying himself.

Two-and-a-half centuries later, an inexpert signwriter was doing much the same thing at Dolgellau, Gwynedd (166). Some forms are almost identical, and the capitals are in just the same spirit. Only a strong continuing tradition could have produced such similar results.

(167) is also at Callington, carved twenty-three years after (165) but surely by the same man. He was still as prolific with his variations, and has now discovered true upright minuscules and non-calligraphic capitals in their West Country form. His script is still derived from sources of perhaps eighty years earlier, although cut with a little more regularity.

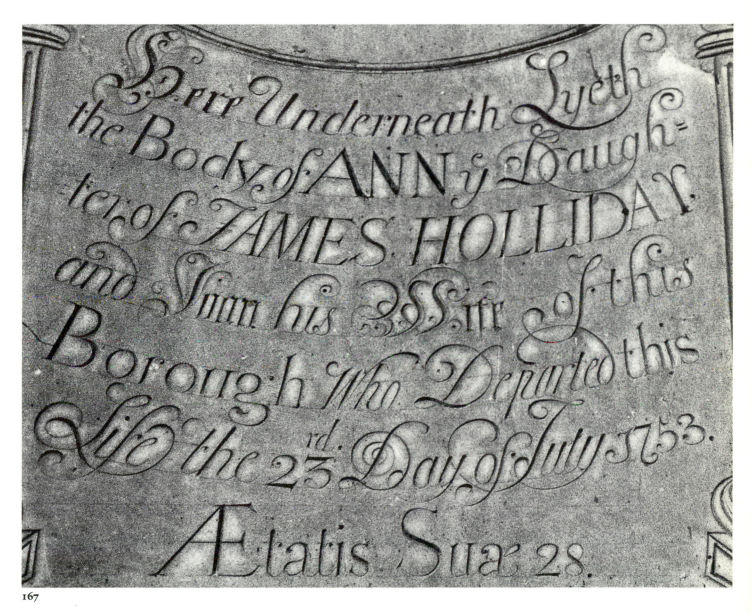

167

The Loughborough, Leicestershire, carver (**168**) has used forms which, although clearly derived from early copybooks, have undergone considerable transformation in the intervening years: developments created by the carvers, partly resulting from the change of material, but no doubt also through a desire to blaze their own path. Stronger than the pen-drawn originals, the scripts relate more closely to the upright minuscules, while providing an opportunity for design-enhancing flourishes.

Although (**169**) from St Mary Castro, Leicester, is nine years earlier, and more crudely cut, it seems to be trying to get closer to the more fashionable copperplate form. Completely lacking the elegance of this, its vigour and honesty has attractions.

For the date, (**170**) from Thurcaston, Leicestershire, is still painfully awkward, particularly in its upright minuscules. The script however is more proficient: it is closer to existing copperplate forms. It still lacks their elegance, is too wide and round and bold; the true copperplate is a sharper letter, with a more sparkling contrast between thicks and thins.

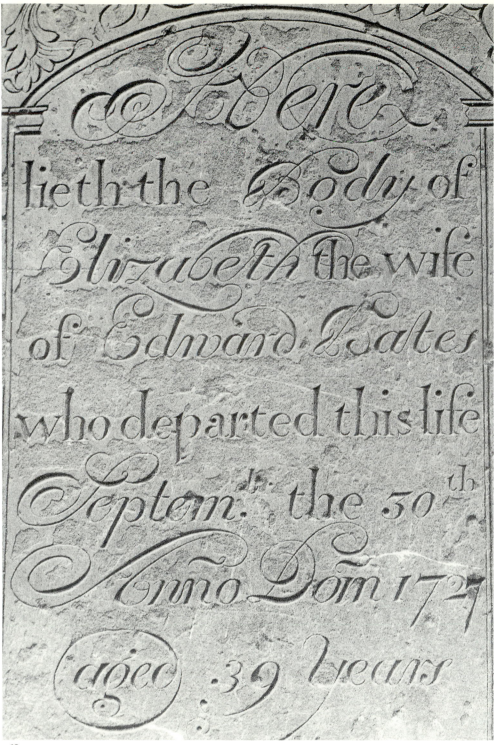

168

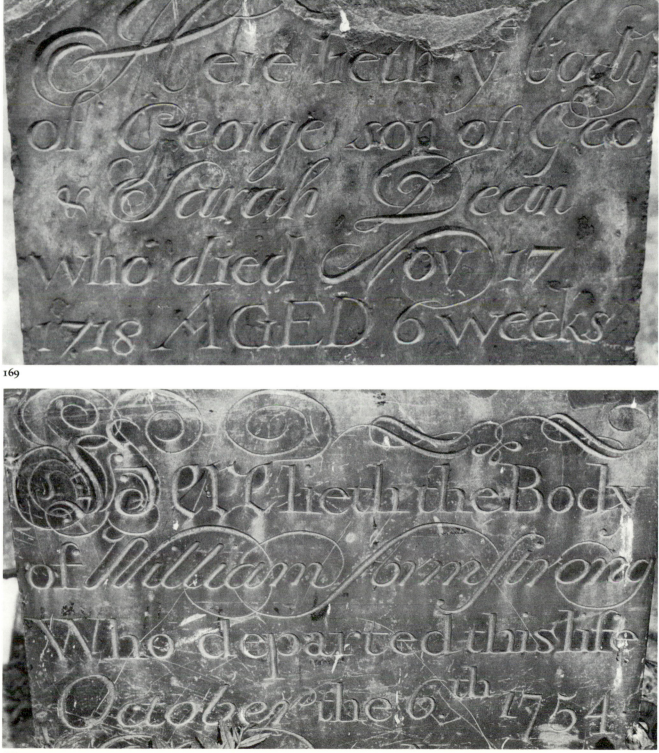

169

170

98

It is recreated entire in two slightly different forms on these two stones (171) and (172) side-by-side at Grantham, Lincolnshire. The design of the scripts and scrolls is derived from copybooks, the architectural surrounds probably from pattern-books for cabinet-makers. The scripts are so completely like their written originals, there seems little to say. From this point on, similar forms were used with assurance, carved or painted; and are still so used today.

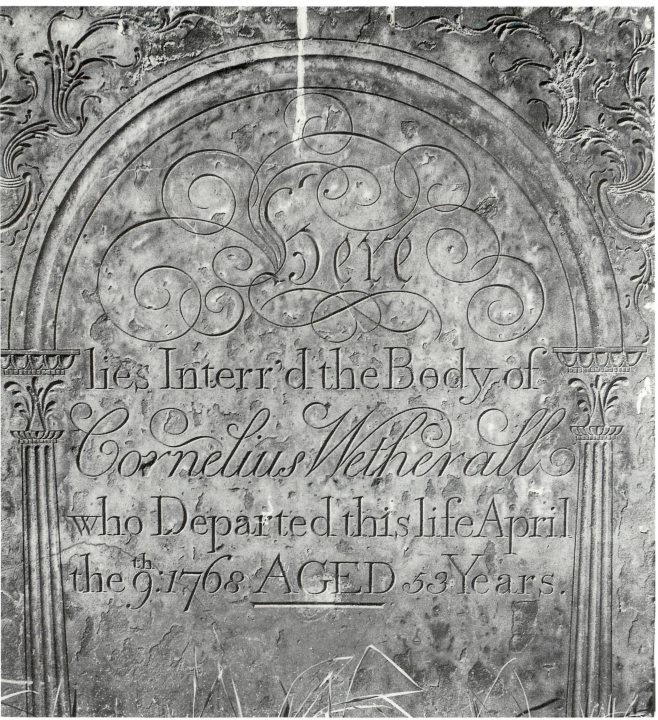

171

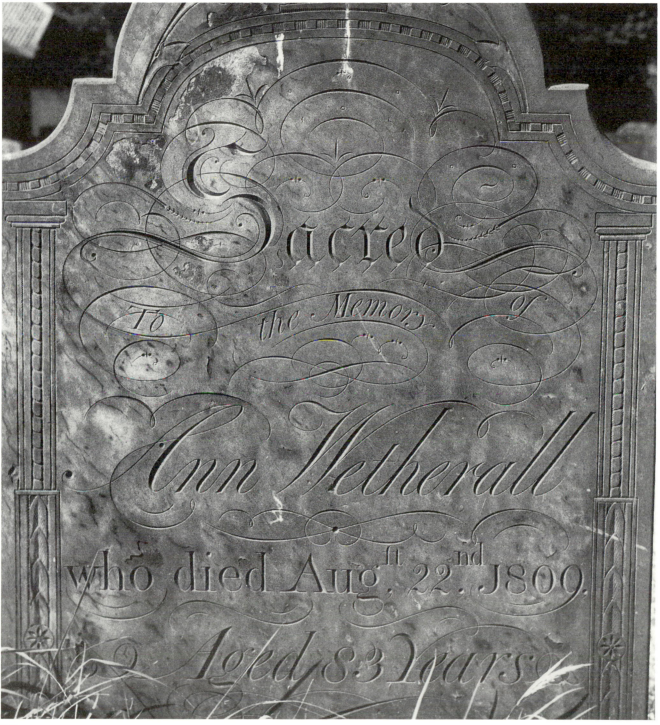

Although it might be thought that such a delicate and graceful letterform would have little relevance today, not only is it widely used – albeit often in bold, shadow, or otherwise 'impure' form – but it is probably the best-executed, the least-altered, of all the traditional styles.

An excellent but by no means exceptional example is seen at its purest, appropriately, in Knightsbridge, London (173). A bolder form is used at Witney, Oxfordshire (174), and this is particularly instructive because it shows how sketchy the signwriters' original crayon marks were – and how little he followed them. They were obviously just a rough positioning guide, the form being built up directly with the brush – which implies confidence and experience. Only a slightly heavy-footed b mars the drawing.

On an ordinary shop in a small village, Middleton-in-Teesdale, Durham (175), a similar weight of letter is given extra richness by a painted shadow. Here the W is especially good, although the curves of the s and e are slightly jerky. While the small gap between face and shadow may be there for technical reasons (the shadow applied before the face is dry) there is a visual gain as well.

But a superb form has been created at Wisbech, Cambridgeshire (176), despite the theoretically shocking idea of using a pen-drawn form as basis for three-dimensional work. This example has been beautifully conceived, the translation from two to three dimensions handled with skill. The necessary thickening of the thins has been achieved without any feeling of heaviness, and the highlights

and shadows created on this gilded letter give a fine edge to the form.

The effect at Westbourne Grove, London (177) differs from (175) in that the shadow is painted as a return rather than as something nearer a cast shadow – although even here there appears to be a fine gap between face and return. The result is a kind of ribbon effect in the thins. Without the return, the contrast between thicks and thins might have been too great, but the total effect is nicely judged.

(178) and (179) are from the same shop in New Oxford Street, London, and have been painted and gilded on glass. They are in reality entirely two-dimensional, but much care has gone into the creation of returns, with shading and cast shadows on these, and double cast shadows on the

173

174

175

background. The section is painted as a prism (truncated at the point for thick strokes). Altogether it is a sophisticated piece of work, with a degree of ingenuity never attempted by signwriters nowadays, although once quite common.

Despite all these tricks – and despite the inexplicable piercing arrow – these forms are a direct descendant of the work of writing masters such as Bickham, although *he* might not have recognised them.

176

177

178

179

A coarser painted script at Girvan, Strathclyde (180) has a kind of highlight on the return, increasing visual interest rather than verisimilitude. But both this example and (181) from Rochdale, Lancashire, are altogether clumsier than those we have seen. This latter three-dimensional script – presumably of wood – has swollen ankles, but it is an interesting form, one which, in its scale and situation, has its own kind of presence.

As, in its different way, has (182) and (183) from Newark, Nottinghamshire. This is carved in wood with a concave section, gilded, given a gilt outline, then glassed over. All this was a standard Victorian technique, although the section was more usually V-cut. The unusual

180

181

182

183

letterform, though descending from the copybooks, has been given a reverse stress: on the whole, but not uniformly, strokes normally thin are here bold, and *vice versa*. Most of the weight has sunk to the bottom. But whoever did it knew what he was doing, and has created a consistent variation on the theme. Viewed as abstract shapes (183) there is no denying the control over form.

Though it is nothing compared with (184) and (185) once seen at Skipton, Yorkshire, but I've never found it since, alas. The bottom line, at least, must have been one of the most spectacular pieces of three-dimensional lettering in Britain. The top line seems, in whole or in part, a later and less skilful addition or repair, and the s is certainly a later addition to 'Merchant'. The slightly wooden awkwardnesses of the top line have, at a quick glance, a certain charm, especially the Cs and o; and I am amused, if puzzled, by the construction of the F and K. I think bits of old letters were used for part of these after a change of name. The h of 'Chew' looks original and perhaps the bottom half of the e and w.

Like the previous example this script has reverse stress, but carried through more consistently. This gives dominating horizontal lines, far more suitable for use on buildings than the dominant angled lines of normal script letters. The condensed form creates a powerful rhythm. Effective subtleties on the lower line, such as the hollowing-out of the basically oval sections, are less well done, even missing, on the line above, and the difference is instructional. They transform mere lettering into sculpture.

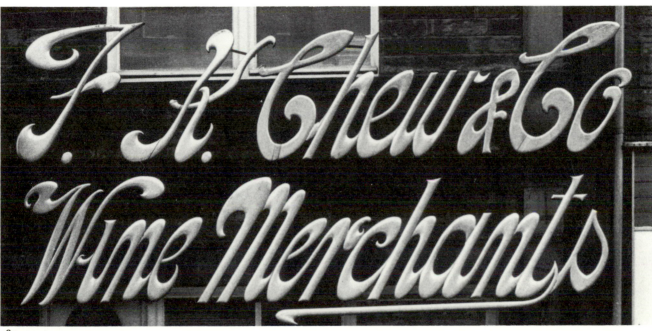

184

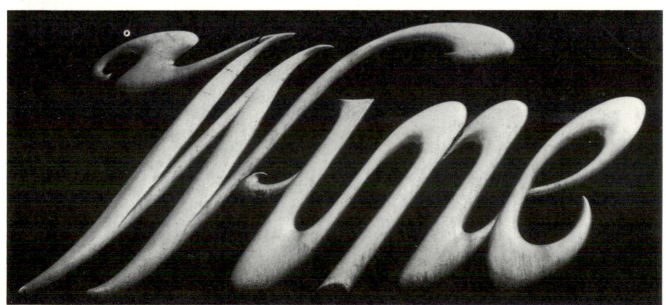

185

Enough of this notice (186) at Malham, Yorkshire, remains to show that the lettering was derived from copperplate scripts, despite the rustic result. Was it done by a signwriter, or the farmer? Whoever it was, used a form unexpectedly like that found on the barrows and carts of Covent Garden market and elsewhere. This script is rapidly cut direct into the wood without marking-out or guidelines; the best is extremely rhythmic, and all versions have very short ascenders and descenders. There seem to be several styles, depending probably on the workshop, and partly on the wood used, but all have consistently designed letters well related to each other. These three carts (188, 189, 190) were photographed in Portobello Road fruit and vegetable market. (187) at Maple Street, London W1, is a non-standard use. (188) is the best form of those here. Wood is not an easy material to carve, but these letters have the fluidity of pen forms and slate carving, with decorative opportunities seized rather than avoided. All the capitals and most ascenders and descenders are given some form of flourish. Even the crudest style here (190) shows an understanding of letterforms, and an ability to adapt them to material and technique.

Although one workshop closed in 1982, after one hundred and fifty years' existence, another still remains in the Covent Garden area, despite the removal of the market.

James Mosley's article in *Motif 11* (Winter 1963–64) has excellent photographs showing the complete alphabet of the form seen in (188).

186

187

188

189

190

Although the archetype of this pen-formed script is formalised and regular, with few real variations, it can be freely interpreted. (191) from Portobello Road, London, has a pleasing wilfulness. The slopes are varied, but the overall rhythm creates a lively pattern, turning what could have been too refined a letter for this quite earthy whole-food shop into something suitably direct and unaffected.

Much more in the spirit of the original copperplate forms, the elegant and flowing – though freely drawn – letters at Dolgellau, Gwynedd (192) seem the proper thing for a flower shop. Imagine the lettering on these two signs switched; how wrong both would be.

Wilder and more ambitious is (193) from Wigton, Cumbria. Not very refined perhaps, but a strong and effective overall design, even if the vigour found in Victorian scripts is missing in some of the doughy curves.

Dominating this script from Dunglow, Co. Donegal (194), the repetition of thick vertical strokes, though derived from pen forms, here look like a bouncing spring; an impression emphasised by the initial flash of lightning. The graphic pattern thus created, together with the spikey shapes, redeems this otherwise banal sign.

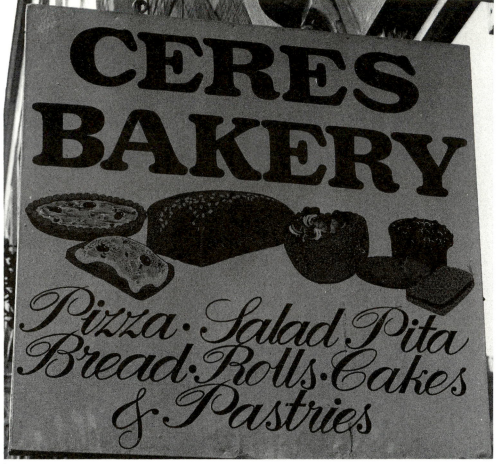

191

192

193

194

b. Brush-derived scripts

Although in a sense the pen-formed script is an informal letter, it has a very formal – or formalised – character in its classic state. By contrast, the brush-derived script is always informal.

Somewhat surprisingly, this script frequently has remarkable similarities with carved italic forms of english letter. Even some of the most freely-drawn and unassuming examples seem closer to these carved forms than to the more self-conscious and contrived copperplate. Such almost extempore lettering (painting with long, flexible brushes, whose thickness dictates the delicacy or massiveness of the letterforms) could be seen on estate agents' boards and many kinds of ephemeral notices. Today it is less frequently practised, despite the rapidity with which it can be executed, and the suitability of the style for such notices.

It is not the only casualty of recent times. A somewhat related style is the one I think of as barrow-boys' Baroque: the rich, rapidly-drawn price labels, their rounded forms (rosy-cheeked, pregnantly Pomona-like) so appropriate for the abundant displays of fruit. They can still be seen on fruiterers' barrows, but their music-hall vulgarity is less evident than even fifteen years ago. Fishmongers had a similar tradition. In their case, the lettering was drawn in chalk (often using the side of the stick for the thick strokes) on blackboards propped up against the slabs or the wall. Both these forms are however rather outside the true scope of this book – they are created within the tradition of those trades, not within the lettering artists' tradition.

The mainstream of this tradition does not divide up into strictly observed differences of style. Purity of style and suchlike ethical considerations do not trouble lettering artists. The pen-derived forms of the writing masters provided models whose perfection was the ideal form to follow, with no consideration given for any really personal interpretations; and despite their beauty, skill and exuberance, the work of the South Midlands carvers,

copying these script forms, reveals little individualism, and eventually it became mechanical, stereotyped, and worn out. It was only when signwriters began re-interpreting this form in wood, in three dimensions, that a fresh and personal vigour was re-introduced. The idea of a pen-formed script being given a real or simulated three-dimensional form is of course theoretically absurd; but, visually, it is a treat, and seemed to open the way to freer interpretations of what could have become a very constricting style.

In contrast, the informal brush-derived script never had any classic, perfect, exemplar. It may exhibit characteristics more truly belonging to the formal style, or it may be entirely built up with little or no suggestion of the brush. In consequence, its interpretation has always shown more variety, and its attractiveness relies more on the standard of taste of the executant than merely on his skill in following a model, although there are certain traditional styles which the craftsman was expected to follow. It is in this way more akin to normal handwriting. It has been claimed, and I would not deny it, that good handwriting is the basis of good lettering; so the quality of recently-executed informal scripts we are examining here probably reflects the general standard of handwriting today rather closely. This, on the whole, is not particularly high, and I think the often somewhat inelegant forms of today – both script and other styles – are the result. They are frequently vigorous, imaginative, and wayward, but the elegance of the eighteenth century is rarely found. Nor are the forms as generally well-drawn as those of the nineteenth century.

The brush-derived forms are more truly vernacular than the copperplate presented as models by professional masters. It says something both for the strength of tradition, and the inborn importance of lettering for the English, that these informal styles are still so well done. Whilst 'English Copperplate' has been a notable export for the last two-and-a-half centuries, I cannot remember seeing any tradition of informal script elsewhere, which can compare with that shown here. It seems unique to these Isles.

195

196

The carved italic (**195**) is from Cocker-
mouth, Cumbria. Its full forms, sharp con-
trasts and fine thins are surprisingly close
to the traditional quickly-painted let-
tering found, until the late 1970s, on estate
agents' boards. This example (**196**) in
Ladbroke Grove, London, must have been
one of the last. The letters were rapidly
painted with little preliminary marking
out. Weight was dependent upon thick-
ness of brush.

A related form is sometimes used for
notices such as (**197**) briefly at Virginia
Water, Surrey. Unfortunately a banal and
seemingly more laborious block letter is
now usual for this sort of work. This
semi-script is, like that on estate agents'
boards, rapidly and freely painted; but
here the thicks join the thins with no gra-
dation, and down strokes begin with a
funny little squiggle where the painter
seems to be turning his brush to form a
point. These strokes frequently take on a
blobby triangular shape as the brush is
pressed down, then withdrawn. The form
derives directly from the brush, and the
way it is handled. I suspect that, once
mastered, it is a quick letter to paint.

See, also, (8).

197

Closely related to the estate agents' lettering is (**198**) from Great Malvern (Hereford & Worcester). Freely-drawn semiscripts of this kind were often used for such notices, and can still be found, surviving more drastic changes elsewhere on the premises. It was clearly a widely-used form for many types of work, and the railway notice (**199**) at York Railway Museum is painted in it. While obviously a form which any signwriter would have had to learn early in his career, one of its attractions is that it is flexible enough to allow personal variations, as can be seen in these examples. It was – and is – good for all those situations where 'just an ordinary notice' is required, such as (**200**) in Chelsea, London. Here, a thinner brush has resulted in a lighter letter, but the basic form is the same – although the capitals seem to have been more consciously built up, and are not a direct product of the brush movements. Some of the minuscules have been titivated up,

198

199

200

too – to their detriment. The style is seen again in its more direct guise on the LNWR carriage of 1885, now at York (**201**). The lettering may not be of this date, but I doubt if the original was greatly different.

The notice at Hampstead, London (**202**) is a little more considered, with a slightly more open look. The tightly-painted sign (**203**) is from Tewkesbury, Gloucestershire.

201

202

203

204

205

The railway notice at York (204) is related to the previous scripts; but with its flourished capitals and letters which in some degree seem built up, it is not such a direct brush form.

Similarly with the spirited and freely-drawn sign from Tenby, Dyfed (205). We are moving away from both pen- and brush-derived forms, to a script which is purely a creation of the twentieth-century signwriter; although the flourished capitals hint at their earlier origins. This example is much enhanced by the painted return and its shadows.

Many of these inventive twentieth-century scripts are as related – or unrelated – to pen-derived scripts as they are to designs derived from the brush. Bold and a little coarse, the slightly plebian fascia at Cullompton, Devon (206) certainly leaves the brilliance and elegance of copperplate some way behind; but it is carefully and consistently built up, with enlivening scrolls and flourishes. Its painted shadow is helpful.

The lettering on painted-over ceramic tiles at Notting Hill Gate, London (207), is revealed now only by the relief outline. Even less elegant than the previous example, its almost naive nature somehow looks porker-like: round and well-fed. Strokes which should be thin are well covered, and some of the curled strokes look more like pigs' tails than the scrolls and flourishes of forms we have seen. There is little relationship to either brush or pen forms.

A fascia at Mullingar, Co. Westmeath (208) creates a feeling of barely-controlled ferocity, although this may largely be suggested by the stake-like crossing of the t. Against the intrinsic character of a script – by nature a condensed form – it is unusually widened out; this is merely Irish perverseness.

206

207

208

Three-dimensional scripts are sometimes
found in wrought-iron or, in the case of
(**209**) from Kinsale, Co. Cork, bent and
soldered wire. Both types of this mal-
leable material are suitable for script
forms. This wire example has its own
shaky charm; the ends of some letters (B,
u, H, t, for instance) have been carefully
thinned out to a point.

The metal ribbon letters at Cardigan,
Dyfed (**210**) are not a true script, for they
do not link; but an effective abstract pat-
tern has been achieved, and the s is par-
ticularly ingenious. Purists will object to
the similarity of e and L; but purists will
have little use for much of the vernacular.

The linked letters of (**211**) at Lost-
withiel, Cornwall, announce the address
of a small metal workshop. A bit of a
throw-away joke, it nonetheless has
attractive details: the comma, the serifs
on the N and S, and a general air of casual
rightness.

Ingenious lettering exploiting unusual
or unexpected materials is a not uncom-
mon feature of the English tradition,
although it is rarely created by the pro-
fessional signwriter.

209

210

211

4. Nineteenth-century vigour

Clarendons

The elegant english letter is the bedrock of the English tradition not only because it was the first convincing evidence of a national lettering style, nor only because of its widespread and continuing use. It is almost literally the skeleton upon which all the other English styles are hung. The classic Roman inscriptional alphabet had letters of varied width, but the proportion of english letters tends to be based upon the square: that is, they are roughly as wide as they are high. This gives for instance wider Es, Ps and Ss than are found in Roman letters, and slightly narrower Ms and Ws. This system of proportion runs through all later English forms.

It is most obvious in the form generally known as clarendon, which is nothing more than a weightier english letter. There is no good reason for this name, but as it is not actually misleading, as 'transitional' or 'modern' are, it is retained here. In type, from which the name comes, the style made its first appearance in the 1840s, but it had been part of the vernacular scene long before that. As can be seen in the following pages, there is no hard and fast distinction between english and clarendon letters, and it is impossible to define at which point the one becomes the other.

An early but fully-fledged example can be seen on Telford's Waterloo Bridge of 1815 at Betws-y-Coed (see 241). Nothing could be more symbolic. The change in England from eighteenth-century elegance to nineteenth-century vigour is encapsulated in the development of this letter. In feeling, half-way between refined horse-drawn transport – horses, leather, dark varnished wood – and the raucous world of steel and steam, it is appropriate that one of its first major appearances should be on an iron bridge forming part of the London to Holyhead road.

The clarendon is a strong and rich form, without the brashness of some egyptians and grotesques. Most Victorian engineering was notoriously over-designed, that is, it was usually VERY STRONG. The clarendon form seems a perfect match, yet it has refinement too, and goes beautifully with all those brass pipes and shiny handles. In the vernacular it is rarely found in minuscule form, if we except what are really coarsely-cut english letters on later tombstones. Together with the grotesque, it was much favoured by engineers and iron-founders; particularly if a bit of a swagger was desirable, as on GWR locomotives. Its sturdy construction, strong drawing and legibility, made (and makes) it eminently suitable for casting; it has been widely used for street name plates in this technique, and in the form of enamelled plates or ceramic tiles.

It can accept a wide degree of contraction or expansion of width without loss of character or quality The ratio of thick strokes to thin, and the overall weight too, can be widely varied. No wonder such a useful and attractive letter became so popular: it is only surprising that its potentialities are less exploited today then those of many other forms.

Seen among examples of environmental lettering from other countries, it looks very British.

212

213

214

GREEN LANE WORKS

216

There is a clear and smooth progression from english letter to clarendon. The beautiful and recently-cut english form in (**212**) at Bath is almost identical to the street name in (**98**) and must be by the same carver. Like those letters it has strong and extended serifs. It seems to have been cut in plaster – a tricky operation. In the instructional-looking sketch of the G – done before or after? – someone seems to be making a point about the vertical stress of the english letter as against the oblique stress of a roman.

The sturdier ceramic tile letters in (**213**) at Newton Abbot, Devon, have serifs which, though shorter, are strong and blunt. The proportions are less sensitive. These letters take their place half-way between the english form of (**212**) and the true clarendon, in wood or ply, from Newport, Shropshire (**214**). The material demands strong forms, so sensitivity has been replaced by robustness, but the forms have regained the full and subtle curves of (**212**). Robust they may be but there is nothing coarse about them. The C and the R are particularly satisfying. The well-judged relationship of thicks to thins is also apparent in the V and the A.

Clarendon at its best is used on the school at Kells, Co. Meath (**215**): one of two such signs, the other announcing FEMALE SCHOOL. Strongly drawn with bold thicks, full curves, and richly bracketted serifs, this is clearly different from though related to english forms like (**212**). It could be called – if such exists – the archetypal clarendon.

Harder, with thicker thin strokes and yet bolder serifs, (**216**) from Sheffield is twenty years later. Curves are more geometric, less subtle; bracketting is more perfunctory.

The assured carved form in (**217**) from Burnley, Lancashire, is further enriched by a generous V-cut; the ceramic tiles in (**218**) at Ilfracombe, Devon, use an outlined clarendon, and are in black and gold. The unusual enrichment points up the important and fashionable nature of the area it names. An even more unusually decorated clarendon, bolder than any we have yet seen, and with simulated three-dimensional effects, is at Cockermouth, Cumbria (**219**), painted on glass. This well-designed letter is probably late Victorian.

In all these examples the bones of the english form lie beneath the clarendon flesh, even at its weightiest. Strokes and serifs are chunkier, otherwise all is fundamentally unchanged.

217

218

219

220

221

222

223

From its earliest days the Great Western Railway used a fine clarendon on its locomotives, and continued to use it until nationalisation in 1948. The original *North Star* dates from 1837; a replica (**220, 221**) is at Swindon Railway Museum. At least by 1840 Brunel's drawings for the railway were printed with a similar, although shaded, clarendon, and it is not difficult to imagine Brunel himself devising this, the first house style of all – and also one of the longest lasting. Apart from rather longer serifs, the letters on *North Star* are almost identical to those of *Caerphilly Castle* (**242**) of about 1923 – by which time the letters had long been completely standardised. Like most locomotive names, these are cast in brass, their design and material epitomising railway engineering.

Cast in concrete or coarse plaster, strongly-bracketted letters at Dunbar, East Lothian (**222**) show the clarendon in unusually powerful guise. These are almost as aggressive as egyptians at their toughest, but the softening curves of bracketting maintain the clarendon nature.

A different conception of this style is on the locomotive *Gladstone* of 1882 at York (**223**). Nineteenth-century letterers often treated numerals with uninhibited invention; as if, freed from word-making, they could concentrate on the abstract pattern.

A later but equally uninhibited variation, with dominating horizontals, is on a Pullman car of 1913, also at York (**224, 225**). Letters can rarely have been more extended. Designed, I suppose, to fit a short word into a long narrow space, the apparent problem has been exploited. (It has also been suggested that they become more legible when viewed, foreshortened, approaching along the platform.) The ingenuity of the simulated three-dimensional treatment is characteristic of railway lettering: not only painted returns with reflected light and cast shadows, but also painted highlights for extra glamour.

The almost even-line painted version from Hull (**226**) retains the full curves typical of the clarendon, which have been sacrificed on the more extreme Pullman car for other effects.

A very condensed form is used for a

cast-iron street-name plate at Huntley, Grampian (**227**). Extreme distortions often result in the curved parts of letters becoming flattened, either vertically or horizontally; thus much of the character of the clarendon, which is usually distinguished by generous curves, is lost.

224

225

226

227

Originally in the roof of Cranbrook Church, Kent, the letters in (228) are of lead. They date from 1771, and can hardly be called clarendon, merely a bold intermediate letter with stumpy serifs; but they are an interesting precursor, with a very English R.

The Cambridge street-name plate seen in (229) has an austerity uncharacteristic of clarendon, with irregularly proportioned letters (wide E, narrow T). The smaller R has a distinctive 'missing' serif. Bolder, and more characteristic of clarendon, (230) is a wood letter at Moffat

(Dumfries & Galloway); the D is stiff and the L has an awkward club foot which is possibly an inept repair.

But the clarendon has richer potential. The smaller and better of the two forms at Keswick, Cumbria (231) has a strong contrast in stroke weight, which demonstrates why the street name opposite lacks richness, for this contrast results in confident curves with a more positive difference between outer and inner radius. The form is further enhanced by stronger and better bracketted serifs, a fine swirly leg to the R, and a more sat-

228

229

230

231

isfactory E, where the middle stem is neither too stubby and insignificant, nor too stalky.

No less rich is the similar metal letter from Exeter (232). The letters are applied to the bridge, not cast with the arch. The date is 1814. There is a subtle difference between these letters and those at Keswick: serifs are sharper, the thins thinner, the top of the A is pointed. The overall effect is more different than these details would suggest; possibly the change of material is partly responsible.

The clarendon has been widely used for many purposes, not least street-name plates. It is perhaps today unduly neglected, for its strong and unmannered construction, with (if properly handled) clear and legible forms, make it technically and visually suitable. Some of the best forms are cast-metal letters, as in (237), but the (probably) plaster forms in (231) are equally fine. They are all legible enough for street names, if perhaps less suitable for motorways.

The enamelled sign in (233) at Great Malvern (Hereford & Worcester) is not quite such a fine form as those just shown, though its smaller serifs make it more economical in width, and perhaps more legible (I make no apologies for contrasting *fine* and *legible*). Somewhat similar, but wider and with larger serifs, is the station name, also enamelled, now at York (234). I would have preferred serifs on the middle strokes of the E.

232

233

234

We have already seen an unusual outlined clarendon used on ceramic tiles (218). More commonly found – and still occasionally used – are tiles with undecorated clarendons. In black and white, embedded in weathered red-brick walls, they are a feature of the London scene at Hampstead. Elsewhere they may be blue and white. Forms vary slightly, and some of the best are found at Ilfracombe,

Devon (235). This three-line showing could do with more interlinear spacing, and less gappy word-spacing; but we must not expect, in the vernacular, the refinements found in good typography. In this example, slight variations of colour in the tiles, and small irregularities in their laying, are entirely to its advantage.

Clarendons are the most usual form for stencils except perhaps for grotesques,

and certainly the most attractive, as can be seen in (236) near Melrose, Borders. Just as it suits casting, its strong construction survives the stencil process. The small divisions give it a remarkably different appearance from a straight clarendon, and a very individual character. In this sign the As and Ms have been reversed.

The mileage plate at Dumfries (237)

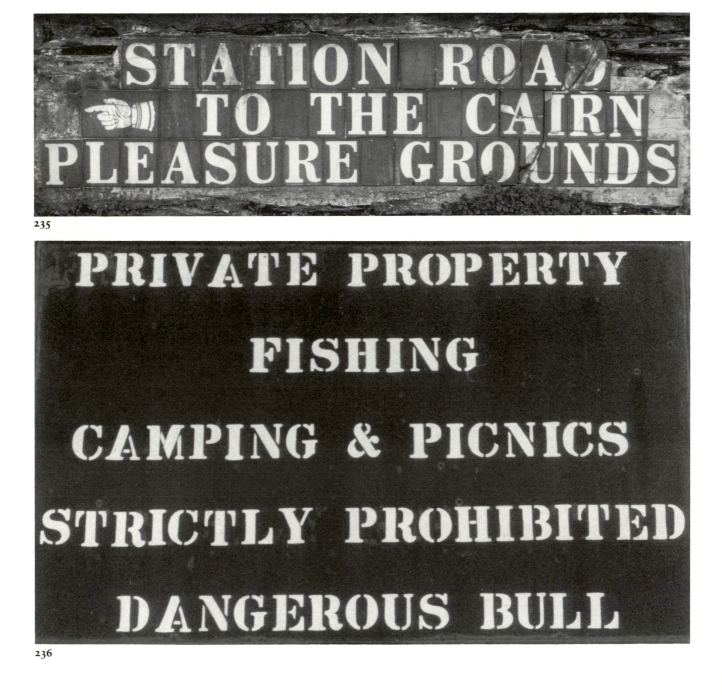

235

236

shows a cast-iron clarendon with unusually light serifs – it is almost an english letter. The letter widths are noticeably regular and well-fitting, the round letters have very full forms with the C and G almost enclosed. The weightier serifs on letters like T and L help to maintain an even colour. The almost voluptuous numerals are a clarendon characteristic.

Why Huntingdon?

Unexpectedly, clarendons were more favoured for casting in metal than grotesques. It is remarkable how many variations are to be found – and their high quality. The London bollard (238) – one of many still around, even if not in their original parish – was never very cleanly cast, and the lettering has been further blurred by paint; but the form was far from merely workaday.

The straight-faced letters on the base of the clock tower at Tredegar, Mid Glamorgan (239), dated 1858, have strong, almost slab serifs. One might have expected something grander for such a situation. Perhaps the choice, with its equivocal message and toy soldier, is deliberate. Are the Welsh trying to tell us something?

Unusually for cast metal, the form in (240) from Kettlewell, Yorkshire, is condensed. It demonstrates not only how appearance can be affected by letter-spacing, but also how sound forms were used for everyday objects as a matter of course. Nowadays a designer would charge a high fee for a similar motif, with probably less appropriate results.

Clarendons also enhance large-scale engineering. The Telford bridge of 1815 at Betws-y-Coed, Gwynedd (241) incorporates a stern clarendon to powerful effect beneath leek, clover, thistle and rose – all in cast iron. The sheer drama of its use wins its place in this book, although perhaps it is engineer's work, not vernacular. In form it is almost identical to the letters in (216) of forty-five years later.

One of the most familiar – certainly the best-loved – clarendons, those used on GWR locomotives were individually cast in brass and riveted to the base plate (not cast with it). This locomotive (242) is now in the Science Museum, London. Like the previous example, there is nothing purely functional here: they are proudly, gleamingly, decorative. The forms cannot be faulted, but there is no sense of over-design: they are enviably right. The casting process has given them a subtle 'character', or deviation from absolute perfection. One of the problems of vernacular lettering is to judge what degree of workmanship is proper to the occasion. Good craftsmanship can actually be quite rough, if the occasion warrants it. All on this spread – even the lettering on the bollard – have an appropriate degree of finish.

Less fine, but with its own cheerful chubby character, is the name from the Southern Railway tank engine (243), ex-LSWR and ex-Southampton Dock, and now at York.

The GWR also standardised its numbers, and (244) on *Caerphilly Castle* is an example. Somehow they don't quite relate to the letters; but although more irregular and more weakly drawn, they have a lot of personality.

238

239

240

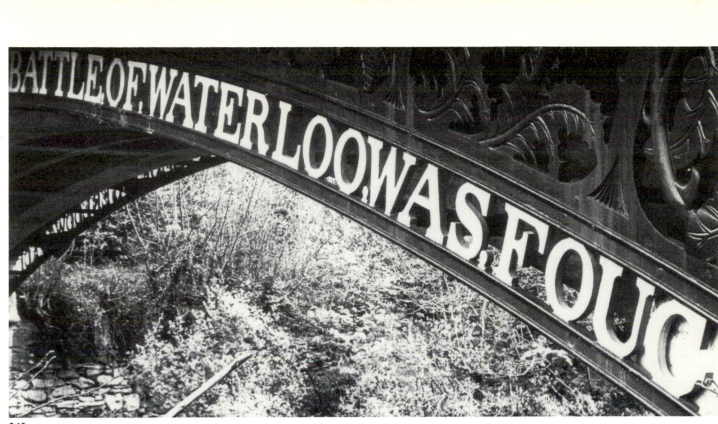

241

242

243

244

The stock letters at Waterford (245) are nicely proportioned, with a good relationship of thick to thin. The serifs might seem small but for the return – made to appear deeper by its skew cut. The letter face cannot be designed regardless of any three-dimensional treatment: each part affects the other.

The third dimension has again been exploited in the splayed-section letters

245

246

247

(246) from Ballyjamesduff, Co. Cavan, and the even more ambitious section of (247) from Roscrea, Co. Tipperary. Both these have bolder serifs than most we have yet seen, helping to create in (247) a particularly powerful form.

The strength of this example is repeated in the painted GWR letters, simulating three dimensions, here photographed at York (248, 249). Careful shading and cast shadows increase the splendour. They are as well designed as the brass letters (242) although, like the numerals, they do not completely relate to them, for the thins are bolder, the serifs bolder and squarer, and certain forms – the R for instance – show minor variations. I don't think it matters much; and technique, usage and scale are so different that a true relationship would be difficult. These painted letters have a chunky square-section appearance quite foreign to brass; nor would the brass letters be easily recreated in paint.

When the LMS used a clarendon – their lettering was less consistent – they favoured a lighter, extended and more elegant version as in (250) on the first-class dining car of 1900 (painted in 1923 colours) now at York. The shadow effects are sleek and subtle.

248

249

250

A rare early pillar box at Warwick (251) uses a condensed clarendon deeply cast, and its decorative qualities echo the fluting on the column. More retiring, the brass letters on the traction engine (252) lack the extrovert quality of, for instance, the best railway designs. Yet more workaday are the standard hardware-store letters applied to the gate at Thoralby, Yorkshire (253); but for their purpose they are admirable. Their spacing on the vertical tongued-and-grooved wood is pleasingly unassertive; sympathy with environment is more important than perfection of form.

An original clarendon of some character is on the canal long-boat photographed at Stoke Bruerne, Northamptonshire (254). Strongly drawn with emphatic serifs, its decorative qualities hold their own against the roses, portholes, and spirited BCN.

251

252

253

254

The combination of clarendon numerals and railway signwriters is formidable. The results are forms to reckon with. The examples here are at York. (255) is on a carriage of 1900; maybe the five is not perfect, the terminating blob being too small, but who cares? The lettering on Queen Adelaide's coach in 1842, from the London & Birmingham Railway (256) is almost identical in style, which is perhaps suspicious; but whether or not these are accurate repaintings of the originals does not reduce their quality. (257), (258) and (259) are of 1887, and are further proof that signwritten representations of the third dimension can be richer than the real thing. Effects are simulated with some licence: accuracy is secondary to impact. The serifs in (258) would benefit by enlargement – those in (257) and (259) are better – and comparison with (255) and (256) shows the basic form to be a little mean.

The fascia from Hackney, London (260) shows how close is railway lettering to the common vernacular tradition. Everything we have been seeing is repeated here: the sturdy form, confidently represented in relief; elaborate shading and reflection effects, far more inventive than one has any right to expect; the decorative result, far more satisfying, if less showy, than many so-called decorative letters. Such letters could have been done anytime during the last century-and-a-half. This is the English vernacular at its most typical.

255

256

257

258

259

260

On such foundations are built innumerable personal variations. An attractive and well-drawn letter (**261**) is from Ulverston, Cumbria. Noteworthy are the expanded form, extended serifs, sensitive personal touches (such as the straightened top serifs to the G, C and S), and good spacing in the long narrow panel. It could have been painted twenty or thirty years ago, but it is closely echoed by lettering on the Dart Valley Railway carriage (**262**) painted in the last few years. The stock is ex-GWR, and this lettering may be an attempt to follow GWR designs; in this it is not very successful.

More personal, and more typical of the 1980s, is the fascia at Blandford, Dorset (**263**). A long way removed from the classic clarendons, its mannerisms include a strong contrast in stroke weight, and extended narrow serifs. It is generally well-drawn and the overall relationships are good.

Another example from the last ten years or so, and typical of them, is the fascia at West Linton, Borders (**264, 265**). The powerful, squat and somewhat stolid forms with contrasting stroke weights are characteristic of the path contemporary vernacular lettering is following. The highlights in the painted returns are perfunctory compared with those on railway lettering, but they enliven the design. The approach is freer, more fluid, more derived from brush movements, than earlier built-up letters. The close spacing and tight fit within the panel are also typical of much work today. It is, it must be admitted, less sensitive, less elegant, far less subtle than earlier forms. The minuscules – as infrequently used today as ever – have oddly extended rs, although

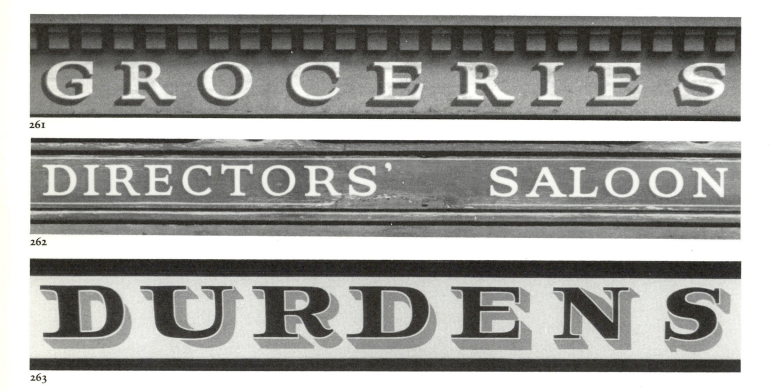

261

262

263

the arm swings deeply round to mitigate the gappy effect (the second one has a shadow missing).

The positive self-expression hinted at there is more evident in another cab door (266), photographed at Dingwall, Highland. These free and confident forms are in a different language from the railway lettering. They verge on the vulgar, especially if closely examined, although the effect in reality, with their bright but carefully chosen colours, is better than would be imagined from the photographs. Much careful work and thought has gone into them, and the stylised representation of the shadows is as involved as the very different railway lettering. There is original imagination at work here – just as there was in the Belvoir tombstones.

264

265

266

Classic clarendon qualities are equally lacking in these fascias from the Scottish borders. Kelso was once noted for a fine set around the town; these have almost gone, replaced by forms getting progressively clumsier yet retaining some virtues. Three here (**267, 268, 269**) lack refinement; (**268**) is made ponderous with its awkward R, repeated in (**269**). But a personality comes through, a desire to achieve something more than standardised, 'perfect' plastic signs. Interestingly, the lettering in (**269**) has similarities with

the form painted direct on the stone string course in nearby Coldstream (**270**). This older lettering is far superior – stronger and better-proportioned serifs, better-judged relationships between stroke weights, a more lively R with its smaller top and curly leg, more subtle shadows; but the squarish forms and overall proportions are common to both. A pity the progression is from (**270**) to (**269**) and not the other way round; the earlier letter has potential.

Far more original are two Irish exam-

ples. (**271**) at Kenmare, Co. Kerry, is an odd mixture. The capital letters are pure classic clarendon, but the minuscules, which marry happily with the caps, and relate well to each other, are entirely original. It is a typical signwriter's aberration, the unexpected solution that enlivens vernacular lettering. The painter has even given the banal AA badge a lift.

Very different and still more original is (**272**) at Wexford. The smaller lettering is not particularly attractive, but the other forceful line – obviously from the same

267

268

269

270

hand as (163) and (164) – commands attention. The S is the weakest letter, particularly the upper curve, but so powerful is the overall character that awkwardnesses are not important. Like (163) – which could well belong in this section – these letters, accentuated by unusually deep returns, recall iron girders (see the feet on the Ms). This Wexford man has a personal and powerful sense of form.

In any other medium, these letters would look dreadful.

271

272

273

274

Another Irish original has done good work in Bantry, Co. Cork (273, 274, 275). Very odd things are happening here. Some of the painted returns are well-defined at their far edge, but most simply disappear into the void. The C in (274) is a surrealist floating form. The other lines of lettering have feet firmly anchored to the ground, but the rest of the letters flying rapidly forward in space. The W is especially weird. I do not know if the effect was intentional, but it opens up new worlds. The basic form is thoroughly competent, the shading, where it appears, is well handled. But these are mind-warping letters. Too many Guinnesses?

275

276

277

278

5. New letterforms for a changed world

It is rather a let-down to return to England and Scotland. Particularly so if we examine lettering on boats today. These photographs, (276, 277) from Dunbar, East Lothian, (278) from Whitehaven, Cumbria, were taken in the early 1970s, and I doubt if anything comparable could be found now. The only boat lettering I've seen in recent years looks as if it has been scrubbed on with a bit of old rope tied to the end of a stick. These here at least show some feeling for letterforms and some skill in achieving them. Their rugged strength suits the fishing world. Viewed as abstract shapes, the numerals in (278) are inventive, well-related, vigorous and original, while the letters are well drawn and strong. The numerals in (277) have a pleasing wavy rhythm, while those in (276) look sturdy enough to withstand the battering of any sea. But if I had started collecting lettering twenty years earlier, my examples of boat lettering would have been infinitely richer.

a. Egyptians

The expansion resulting from the Industrial Revolution, and the increased importance of commerce, directly affected lettering, which one can almost call the life-blood of commerce. In print, types had to get brasher and more attention-gaining, and founders vied with each other in bringing out more and more brutal forms. Signwriters and lettercarvers were not unaffected; rather, they were ahead of the typefounders in introducing new forms. But even here, the innate British feeling for lettering was still in command, and instead of the new forms being merely loud and coarse, they had their own kind of beauty, sound proportions, and rich vigorous shapes. Instead of killing it stone-dead, they gave the English lettering tradition an extra dimension. And they gave it new forms which were remarkably adaptable: forms appropriate not only to the changed world of Victorian times, but which can be modified to suit the world, changed yet again, of today.

Later in the nineteenth century, decorative letterforms flooded out of typefounders and lettering workshops. But earlier, in the second decade of the century, two designs of greater long-term importance had already emerged: the egyptian and the grotesque. The former has slab serifs; the latter is an egyptian without serifs. Of the two, the latter has proved to be the real long-distance runner, but the egyptian is nonetheless a powerful, important, and still valid form. Its name, like 'clarendon', is a meaningless derivation.

Following what appears to be a general rule, the new typeforms were predated by lettering produced by architects, masons, and signwriters. Few major buildings appear to have been adorned with either egyptian or grotesque letters in reality – despite whatever the architect may have indicated on his drawings – although both are ideally suited to architectural use. But the styles were eagerly seized upon for less portentous buildings – pubs, banks, chapels, monuments; by manufacturers of stock letters for shop fascia use; and by iron founders.

The egyptian had (and has) all the advantages and adaptability of the clarendon, but with a more elemental character. The clarendon, for all its sturdiness and strength, has a politely civil air about it. With the egyptian, it is rather as if the word 'please' had been omitted.

140

279

280

281

282

283

It is extraordinary how little use has been made of the egyptian in architecture. Slab serifs create a closer relationship to architectural rhythms than even sans-serif forms can generally achieve. But their use in this situation is so rare. The frieze of lettering on the Pharmaceutical Society building in Bloomsbury, London (279) – a building remodelled by John Nash in the late eighteenth century – was not put up until 1860 when the top storey was added. This is the finest example I know of the architectural use of egyptian forms. Beautifully proportioned and spaced, with geometric curves, regular stroke weight, and well-judged serifs, even the straight leg of the R, which can look clumsy, is a positive virtue: firm and authoritative. It was for such use that egyptians were dreamt up; but it was left to vernacular letterers to use them.

The hotel name at Coleford, Gloucestershire (280) is characteristic: so nearly like the previous example, yet much inferior. Both are incised with V-cuts; but uneven proportions (compare N and E) and uncertain curves make the humbler example – which, seen on its own, without this rather unfair comparison, is a powerful form – definitely plebeian.

The vernacular letters were more successful in other fields. Some fine street-name plates use egyptians, such as the chubby one at Wragby, Lincolnshire (281). These letters – related to many typefaces of the time – are bolder than normally suitable for architectural use, but suit their use here. Although the K is a bit odd, these are more successful letters than those in (280).

The weight has so increased in the Barnard Castle, Durham, tombstone (282) that counters have almost disappeared. But these Billy Bunter letters, which in unskilled hands could have become gross, are well-controlled.

The light condensed form in (283) on a tombstone of 1839 at Dalton-in-Furness, Cumbria, is again reminiscent of typefaces of the time. So flexible is the egyptian form that it can be designed to create the angular, geometrical effect seen here and in (279), or emboldened, with subtle curves, to provide the mellow character of (284) at Ross-on-Wye (Hereford & Worcester). This is an unusually gentle egyptian – a form not generally noted for elegant effects.

A signwritten version on the Liverpool & Manchester Railway carriage of 1834, now at York (285), uses some nice three-dimensional effects; but for ingenuity a tombstone of 1846 at Egloshayle, Cornwall (286) has few challengers. A light V-cut egyptian has been surrounded by engraved lines in what appears to be an attempt to simulate signwriters' simulated shading representing a triangular relief letter. If that sounds tortuous, so is the letter. It is difficult to work out what three-dimensional form the cutter had in mind. The flights of fancy have distracted him from more mundane matters such as relative proportions, spacing, and even, in the Y, drawing.

Another trick played with egyptians was to reverse the stress, and an example of 1846 from Great Torrington, Devon (287) shows very strong slab serifs combined with extremely light verticals. The letters become, effectively, two horizontal rules.

284

285

286

287

Four egyptians in relief show a wide range of effects. At Workington, Cumbria (288) a light version with unusually small serifs is nicely related to surrounding architectural detail. Its even-weight unassertive form lacks the authority of (279), but it looks at home here. Nearer to the classic form is a smallish medium-weight letter at Ulverston, Cumbria (289). The geometric shapes are well spaced along the fascia to make good architectural pattern. In detail some letters lack refinement: the E is narrow, and frequent painting has blurred the original sharpness, but the overall effect again demonstrates the sympathy existing between these letterforms and architectural forms.

More solid and in almost square-section relief, the powerful closely spaced shapes at Wexford (290) lack only refinement in finish to make them classic forms – and some of this roughness is the result of weathering.

Letters in general, and egyptians in particular, have been well exploited on the chapel at Great Torrington, Devon (291).

Heavyweight forms have forced the letters into ungeometric shapes, and inconsistencies such as fine crossbars to H and A are required to maintain legibility. These powerful little forms, a sudden patch of deep shadows, busy angles, and rich curves, in a capricious frame, are surrounded by large plain surfaces. The effect is accentuated by the deep relief, which suits the egyptian (and the grotesque) as it would suit few clarendons and only the very sturdiest english letter.

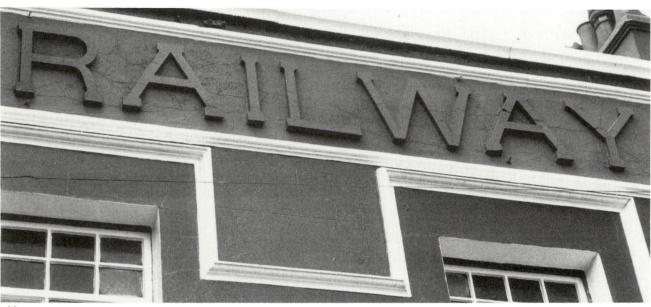

288

289

290

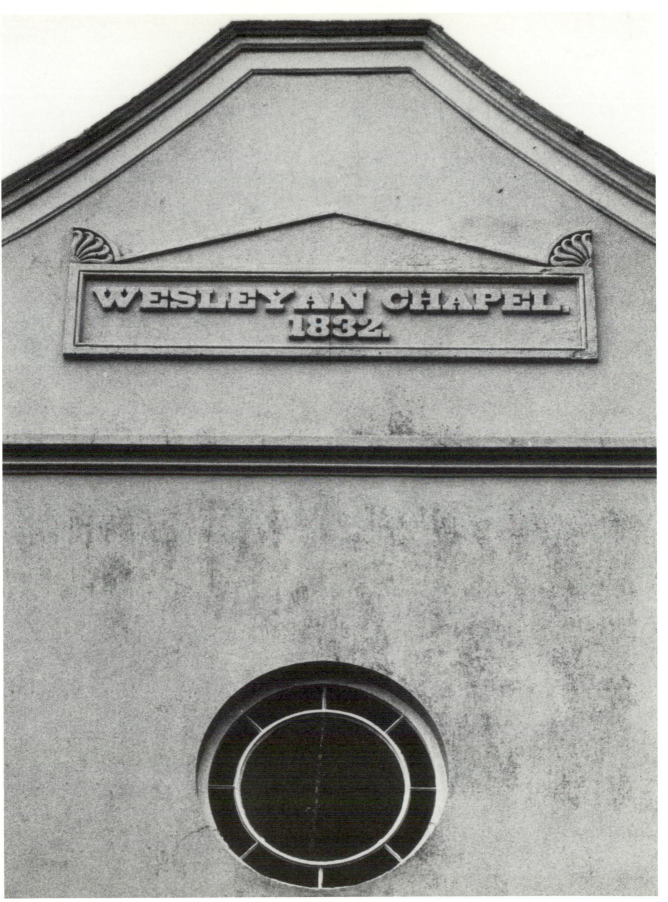

Not too successful as signposting is a cast-iron mile-'stone' at Clonmany, Co. Donegal (292). The cylindrical form – rare in itself, fortunately for travellers – uses a cast egpytian of equal rarity. The condensed letters necessary for this impractical cylinder have a convincing character in themselves, well-designed and shapely. But regarded as an object for imparting information, the conception is not well thought out.

The Cheltenham street name (293) is another matter. Generously proportioned letters, well spaced, make a clear and strong statement. Cut into the plate only a few millimetres, the horizontality created by slab serifs, aided by the slightly expanded proportions, is strongly architectural. The R, sometimes a tricky letter, stands firmly with its straight leg, and the G is very satisfying. Strokes are subtly not quite even-line.

More eccentrically designed letters are used for a brass locomotive name at York (294). Identical lettering was used for *A S Harris* of 1907, belonging to the Plymouth, Devonport & SW Junction Railway before absorbtion by SR. With slighter serifs, a positive difference between thick strokes and thins, and less assured round letters, it is less architectural than the previous example.

The egyptian was widely used in the nineteenth century for stock letters. (295) from Waterford and (296) from Kilrush, Co. Clare, are ceramic letters treated to (not) look like marble. Their complicated skewed section is characteristic, as are their sound proportions and sure forms. Available in many sizes, in plain white as well as 'marble', used tightly or widely spaced, they are a welcome addition to any fascia.

The enamelled station name plate (297) is now at York. The bracketting on the horizontal strokes of E, T and L give it the effect of a clarendon, but most serifs are unequivocally slab.

We have already seen reverse stress in (287); a wild signwritten example at New Ross, Co.Wexford (298) is strongly italicised too. Apart from a slight gap after the B it is skilfully done. It speeds along the fascia; I'm not sure how appropriate it is for use on a building, but it is an original conception, well and consistently carried through.

292

GROSVENOR STREET

293

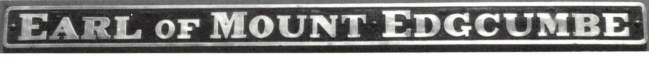

EARL of MOUNT EDGCUMBE

294

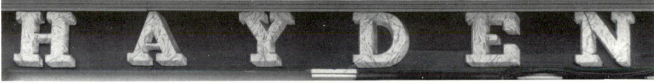

HAYDEN

295

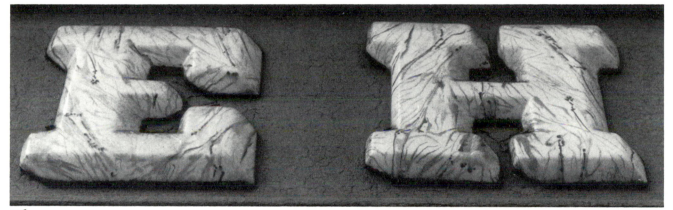

296

WELNETHAM

297

JAMES BYRNE

298

b. Grotesques

The second letterform apparently a reflection of the Industrial Revolution was the grotesque. It seems to us now the almost inevitable progeny of the clanging, crashing, smoking world in which it grew up, but in reality its conception was due to totally different circumstances: the desire of architects and their intellectual advisers to create a letterform suitable for their neo-Greek visions. Having their own individual conception of the Greek world, they believed the more barbaric the form, the more Greek it would be. 'Rugged antiquity' was an idea which appealed to those who saw primitive virtue in the Noble Savage. The rational simplicity of a letter without serifs would, it seemed to them, be eminently appropriate for their austere and elemental buildings.

And in theory, they were quite right. These new, strong, simple shapes *are* most suitable for buildings in general, and neo-Greek or neo-classic buildings in particular. But, somehow, the lettering so carefully indicated on the architects' drawings rarely actually got put up. I have only found one true example, on the Shire Hall at Brecon (299). It appeared on Philip Hardwicke's late and greatly lamented Euston Arch of 1835, but there the lettering was not added until the 1870s. If English signwriters and, later, typefounders, had not appropriated it for their own base uses, this serif-less letter – the creation of high-minded men with their eyes turned towards a hazy golden past – would have perished in the factory smoke.

The originally somewhat disparaging term 'grotesque' has of recent years generally supplanted numerous equally irrelevant names such as 'doric' and 'gothic'. The proportions of its basic, uncondensed or unexpanded, form follow the English preference, the letters tending to be as wide as they are high. A sub-division, often called sans-serif, has proportions based on the more classical Roman system. Like all the main nineteenth-century forms, it can accept extreme variations of weight and width.

It is a letterform which has undergone a lot of development, especially by typefounders, in the twentieth century, and these modifications have mainly been attempts to create greater regularity and conformity between the letters of any one alphabet, and also to try to achieve a greater family likeness between the different weights of a type style. Such methodical and rational desires were not of great importance in the nineteenth century, and the mild inconsistencies between letters of the same alphabet frequently gave the lettering a characteristic Victorian vigour.

Architects may have forgotten to use the new lettering on their buildings, but signwriters and lettering artists exploited it enthusiastically – to many people's horror. Time and time again they appeared on shop fascias and pubs, as well as on more ephemeral notices. They made a convincing and quite early appearance on another iron bridge (see 308, 309) – in the manner of Telford's Betws-y-Coed bridge – and demonstrated their eminent suitability for this engineering age. They could be deeply and richly carved into stone, or built up into equally rich three-dimensional wood letters – both techniques adding a noble full-bodied character to what might seem a rather austere basic form. They were, of course, excellent letters to cast, and were used in the form of cast-brass plates to carry the names of many notable railway locomotives. The railway companies also achieved especially rich results by painting them with strong and complicated shadow effects. And, today, signwriters still exploit this simple form, giving new interpretations which would have disgusted those stern neo-Greek architects who were originally responsible for its conception.

The Shire Hall at Brecon, Powys (299) shows the type of building for which grotesques were devised. This belated example is the only one I know showing them correctly used. The incised square-section letters are even-line and geometric, thus correctly 'barbaric', and were surely designed by the architect. Strictly speaking, they are what we now call sans-serif letters. The theory behind these letters, although of dubious logic, is seen here to be visually sound.

How grotesques were generally used in practice is more truthfully shown in (300), off Portobello Road, London. Although of even weight, there is no attempt to achieve elemental simplicity. The forms are not geometric: round letters are ovals and, as opposed to sans-serif, whose classically-derived proportions can be seen in (299), proportions are those of what we now call grotesque. These letters, rather large for the building, dominate the mews, although they are neither strong nor particularly good.

299

300

148 The grotesque can be a distinguished form. The shapely letters V-cut in granite are at Billingsgate, London (301). The building is of 1813–17, but there is nothing neo-classic about this side of it; nor, although these letters may have appeared grotesque at the time, is there anything primitive or barbaric about *them*. The wide spacing of the slightly condensed letters gives them a noble monumentality. The squaring-up of round letters is characteristic of the grotésque, particularly in vernacular use. No other style is so frequently treated in this way, nor is it so generally apparent in type. It can be seen to a lesser degree in the station name in (302), once GWR but now Dart Valley. These practical, unex-

citing, unpretentious letters are firmly drawn and consistently proportioned. Signs with similar lettering are still at Paddington, and were once widespread on GWR routes.

A wood letter at Galashiels, Borders (303) also shows slight angularity in its curves, and similar condensation. Its strong forms are reminiscent of some nineteenth-century types. Although unpretentious, it has refinements such as the thinner centre stroke to the E and a well drawn R which set it apart from simple block letters cut by the local odd-job man.

A more sophisticated wood letter (304) at Langholm (Dumfries & Galloway) has round forms which are quite circular, and the splayed skew-cut section which is so common in stock letters. These simple-

seeming forms are given additional nobility by the wide spacing.

Some solid carpentry has produced forceful letters at Blackburn, Lancashire (305). The rounded-off section with its flat face accentuates the robustness of the slightly expanded forms.

The extreme condensation of a triangular-section relief form at Manchester (306) results in the angularity of letters such as O and S. The M is awkwardly narrow – emphasised by the open character of preceding letters – but otherwise these are well-conceived if badly spaced forms with an effective insistent verticality. Related forms can be found in nineteenth-century types.

301

302

303

304

Similar in many ways, even to the angled cut-off on the S, are the yet more condensed letters on the fish box (307). These are approaching the feasible limit of condensation, and they demonstrate to what extremes the grotesque, unencumbered with serifs, can be taken. Extreme condensation, where legibility is easier to maintain, is more common than extreme expansion.



Although grotesques were devised to suit neo-Greek preferences, they were by chance equally suitable for the burgeoning engineering and industrial artefacts. The bridge in (308) and (309) is at Abermule, Powys. It was built in 1852. Considering how successful the lettering is, it is surprising that such use was not repeated. (309) shows the exceptional sympathy grotesque forms have with the metal construction: they are of course themselves part of the construction. The rather condensed forms have, as an expression of their function, straight-sided round letters – not so different from those in (303). Strong letters contrast pleasingly with delicate lattice-work above.

Railway locomotives are also pieces of

308

309

heavy engineering but, because more precision is required in their construction, and because of the aura surrounding them, well-designed and well-formed letters were a necessity. Partly a matter of pride, it clearly would not do to use roughly finished or incompetent forms for a piece of machinery named *Agamemnon, King Arthur,* or even *Duchess of Hamilton.*

Unlike the GWR's individually cast letters riveted to baseplates, the other railway companies cast their brass plates complete with lettering. The letters were slightly shallower than those of the GWR.

(310) shows five names from the LMS Jubilee class of 1934. Generally the LMS used very similar letters for all their locomotives, but there were sometimes small variations from class to class. Small differences *within* the class were the result of the engines being built in different workshops. The longer names of the LMS Coronation class of 1937 necessitated a slightly condensed version of this design.

The two names in (311) are from the SR King Arthur class of 1925. The Southern used a more varied range of grotesques for their names than the LMS, although they were consistent within each class. Lettering for the King Arthur class was more expanded than for others. It has a distinctive R and a slightly awkward G.

The five names in (312) show the variety of Southern grotesques. *Eton* is from the Schools class of 1930, *Trevose Head* and *Selsey Bill* were given names upon regrouping in 1923, *Hackworth* is from Remembrance class of 1934, and *Drake* from the Lord Nelson class of 1926. All are pleasing, with certain individual characteristics: in the expanded forms, wide letters have straightened horizontals, while in the narrow forms the verticals are straightened.

The cast letters used by LMS and SR were sound, slightly anonymous grotesques. It must be said they lacked the character of GWR's clarendon. But well cast, proudly displayed, repeatedly polished, they looked good.

All these examples are at York.

310

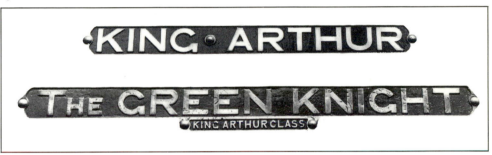

311

312

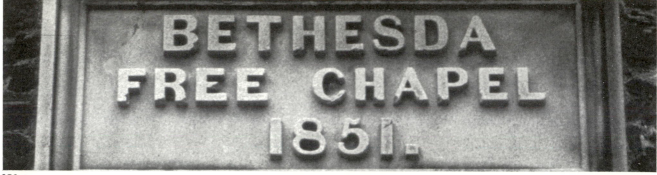

313

314

315

316

317

The grotesques on this spread have, by various means, been given a richer character than those on the previous two pages.

Some letters at Keswick, Cumbria (313) are of a slightly less common form of grotesque, with a positive contrast between thick and thin strokes; although the terminations of the S would be better thicker, these are well-designed letters, if a bit chipped.

The contrast between thicks and thins is also the characteristic of letters at Bolton, Lancashire (314). Such details, here and at Keswick, have a disproportionately large effect on appearance. The S here is more successful, although the M could have been a little wider.

The early railway lettering at York (315) is from a carriage of 1846 on the Stockton & Darlington Railway. Within the return effect are lines resembling those in a woodcut. A somewhat similar basic form with different shadow effects was used on the LNWR post office van of 1885 (316) also at York. The rhythmic form of the S is more satisfactory, and the acute terminations to the C relate to it just as the horizontal terminations of S and C in (315) relate. The double cast shadow, and the complications of shadow, highlight and reflected light within the return, are typical of railway lettering at its most ambitious.

Identical to much late-Victorian lettering is the sign in Marylebone, London (317) which must have been done within the last thirty years. It has a finely-judged variation between thick and thin, strong round forms, and – not least – rich shadow and reflected light effects. As in many grotesques, the curly leg to the R has given way to a straight form; but this is well balanced.

That straight-legged R can be seen again in (318), on an LNER locomotive of 1936 at York. This close-up shows how abstract the shadows are in their pattern. The letter face is gold, the unrealistic tapering 'highlights' are white. Formalisation is here at its most perverse.

More realistic are the effects in (319), from the same LNWR van of 1885 as the post office lettering in (316). The generous rhythmic forms, with their double cast

shadows, are a perfect embellishment for the panelled carriage.

The lettering in (320) might be from a carriage belonging to the Yorkshire Dales Railway of 1882. In fact it is on a shop fascia in Kirkby Lonsdale, Cumbria,

1982. The short name in a long narrow panel has been extended to echo – perhaps unconsciously – the moulding below. There is nothing here to indicate that skills are being lost. The letter face is gold – another link with tradition.

318

319

320

An instructive comparison can be made between the LNER name of 1935/37 seen in (**321**) and the LNWR plate of 1873 (**322**). Both are at York. The earlier plate, with letters recessed and blacked in, uses a characteristic nineteenth-century grotesque. It is a sturdy form with several eccentricities, a clear contrast between thicks and thins, and curves whose perfectly circular outer radii are made to look ungeometric by their oval inner curves. *Mallard* however is a cast version of Gill Sans, which LNER settled upon in 1934 after using, generally, a slightly con-

321

322

densed angular grotesque. Early versions (*Cock o' the North* and others) were too closely letter-spaced, but later this was usually better – especially for short names like *Mallard*. For a couple of years, four of the first A4 (Silver Link) class had slightly inaccurately signpainted names in a form of Gill Sans Shadow. Later, some names were slightly bolder.

Comparison between (321) and (322) reveals the difference between the severe and classically-proportioned sans-serif, and rumbustious nineteenth-century grotesques. Since the 1950s, taste has to some extent veered back to the more colourful grotesques; but grotesques which have been worked over in the perfectionist spirit of letters like Gill, while attempting to retain the earlier vigour. Perfect and

true relationship between each letter of the alphabet is a preoccupation of responsible twentieth-century letter designers, particularly type designers, as it rarely was in the nineteenth century.

From the pure and non-vernacular air of Gill, we return to forms which would have had Eric Gill tearing his beard out. Two examples here have no curved lines at all. At Wexford (323) shadows and reflections on a gilded V-cut incised letter create a facetting effect; while a more recently painted and more expanded letter at Town Yetholm, Borders (324), with too wide Es, is solidly chunky. The graceless form has its uses, and a bold version is fashionable in American colleges. The straight lines suggest architectural possibilities.

Very different is (325) from New Ross, Co. Wexford, which has the same forceful sculptural power as lettering in nearby Wexford. There cannot be many examples with such an expressionist impact as this man's lettering. I don't know how it is achieved. The suggestion of deep relief, accentuated by the absence of any system of perspective for the returns, must be partly responsible. Vigorous contrast between thicks and thins and a personal interpretation of the forms of various letters (here, R and A) must contribute. It demonstrates that a convincing and assured sense of form can override generally accepted restraints. These letters are a long journey away from the form of Victorian vernacular; but are redolent of its spirit.

155

323

324

325

326

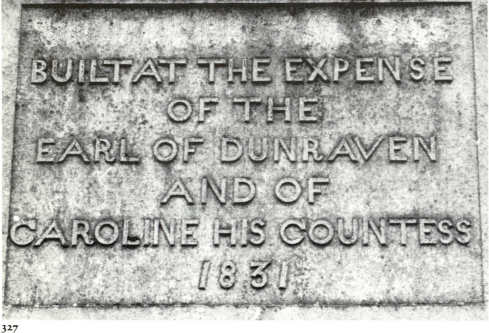

327

Almost the reverse could be said of (326) at Hertford. The forms themselves are rather flaccid, it is only the technique of terra-cotta tiles which gives them interest. Small irregularities, the tooling around and in the form, the ridge around slightly sunken faces, the rounding of angles where strokes meet: such things help one overlook the unpleasant shapes of, especially, C, R and S. The weaker forms show the dire influence of art nouveau, much watered-down. Yet the lettering as a whole is consistently worked out, and as an incident on a wall it is to be valued.

Very different is (327) at Adare, Co. Limerick. The basis of this would seem to be the Greek-inspired 'barbaric' letter, but interpreted by a rustic stonemason. Adare is some way from the centre of things. Taken for what it is, I find it has a lot of charm, with its nice curly R and, at heart, geometric letters. The Cs have serifs.

One is aware of a human hand at work here, carefully chipping away the background stone.

Normally the stacking of letters, as in (328) at Penzance, Cornwall, is not desirable; but here a fine abstract pattern has been achieved, exploiting the shape of this particular word. Words are shapes as well as sounds. On this scale, slight roughnesses in execution are immaterial, possibly actually desirable. The geometric O and ungeometric S do not clash, and the rather exaggerated form of the E is all gain.

Vernacular work is far from lacking in wit, which can be found in wording, form, placing or, as in (329) at Killarney, Co. Kerry, material. Both the painted and rope 'wool', avoiding whimsey, are low-keyed, almost innocent, in their treatment, and are all the more appealing because of that. The extraordinary iron sign above speaks the same language.

328

329

330

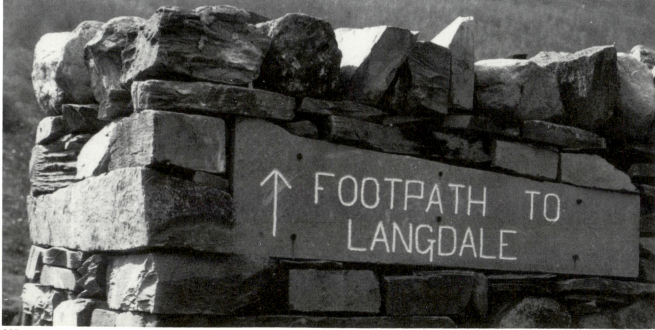

331

The same kind of honest and direct approach is used on a gate near Padstow, Cornwall (330). Not only is it a visual surprise and effective signposting, it still keeps the cows in.

Very different, though equally unsophisticated, the sign at Little Langdale, Cumbria (331) is exemplary: simple, effective and fitting. Such slate signs with gouged-in lettering are widespread in the National Park, fitted into the dry-stone walls, or on boot-level posts: always noticeable, never obtrusive, their material indigenous to the district, their letterforms plain, almost primitive, following the style here.

Having to go to the post office at Easky, Co. Sligo, to hand in the camping site keys, I was surprised to find it shut at nine o'clock – as was a man waiting to get his morning paper. 'However', he said quietly – with not a person, nor a car, nor even a cow, in sight – 'the main thing is, not to get excited'. Waiting, unexcited, I saw further along the street this window (332). So the power of the grotesque is appreciated even here. I suppose one could call this vernacular use. They are actually rather good forms – a fine bold condensed contrasting with squarer bold capitals: excellent letters, strongly nineteenth-century in feeling. These would have been printed from wood type. We have seen forms like the lower line of capitals already; but nothing like the condensed lower case seems to have been used in the vernacular – more is the pity. A line of approach for letterers today?

6. Decorative reaction

Decorative letters are limited to no period or country. The English have always been prone to add twiddly bits to the forms, or to work patterns into such parts of the letters as provide enough space for them. Most early examples are merely regular forms of letter which have been decorated. By the middle of the Victorian era, decoration had gone far beyond that: it became the letterform itself; often, in fact, overpowering the form. In this, it followed one of the more provocative (and misunderstood) dictates of Ruskin on architecture: that the structure of the building was merely a necessary expedient to hold up the decoration. He was pre-supposing a well-designed structure: decoration was to grow out of it, turning mechanics into art. This vital qualification was too frequently ignored. In lettering it often resulted in some fine decoration on ill-understood letterforms. Pattern and decoration derived from or emphasising the form – including the pattern developed from shadow effects – seems more successful than most applied decoration. But the mania for decoration overwhelmed all Victorian applied art: perhaps not only a reaction against 'boring' Georgian plainness, but also an expression of some innate popular English prejudice.

The most extreme and prolific decorative lettering appeared in the form of type, as founders vied with each other in a competitive market to produce increasingly bizarre designs. While much was vulgar or illegible (the designs became particularly nasty when carried away by medievalism) there were many inventive and, in their way, beautiful types. As in architecture, all periods were plundered for inspiration, and no effect or idea was too scatty to be exploited.

Such a heady atmosphere could not be ignored by signwriters and letterers, even had they wished to; but because of their method of work and the materials with which they worked, equivalently florid designs were less common. What they often had at their command, which printers did not have, was the use of the third dimension. This was frequently well exploited, particularly in the sections of the letters. Combined with the fall of light – from variable directions – this characteristic allowed effects unattainable in type. The section might be flat, concave, convex, V-shaped, U-shaped; have lines cut in it, or built up on it; be patterned in any conceivable manner,

again in relief or in intaglio. It can be gilded and glossy, or in stone and matt. It can be of cut glass, etched glass, cut sheet metal, bent and welded metal, ceramics, terracotta.

The signwriter painting flat letters on a flat surface has of course fewer effects to aid him; although as we have seen his representations of three dimensions are frequently more astonishing than the third dimension itself.

Lettering is basically a fairly simple craft, but disaster always threatens and is frequently victorious. It might be easier to achieve a superficially more attractive design with decoration, for sometimes this can disguise faults of proportion or spacing which would be immediately apparent in plainer styles. But the Victorians were fairly adept at avoiding disorder, no matter how ambitious their ideas. Some of their most adventurous work appeared in fairgrounds, and this is the biggest recent casualty in the whole of the vernacular tradition. From some of the most inventive lettering ever executed – one of the last strongholds of true Victorian and Edwardian vigour – there has been over a period of about fifteen years a dizzy descent to appalling banality. The rowdy Baroque forms, so right for the fairground, have now vanished, replaced by lettering which would disgrace a child's comic; incompetent even when judged on its own level.

This book tries to show the English vernacular tradition as a whole, and as a continuing affair. In much of the lettering shown, plain or decorative, one can point to failure after failure, in whole or in part. Many recent decorative designs are particularly unsuccessful. Yet they are in many ways preferable to the blandness of much High Street lettering. The use of a living tradition is more satisfying for us, the passers-by, and it is more rewarding for the signwriter. Face to face with his limitations and defects though he may be, he is a thinking man, not a tool.

We have already noticed the English inclination for swirls and flourishes, or strokes extended into curlicues. These two stones from Hickling, Nottinghamshire (333, 334) are fine examples, some way removed from their calligraphic sources. The first, in relief, despite its latish date of 1742 incorporates some rather primitive undecorated forms – almost by a different hand – and some ligatured letters in 'Margaret' where the carver amused himself. The second, although of 1720, is more skilfully cut, with good minuscules as well as the beflourished capitals. The two Ls of Gill are linked by a delicate lovers' knot. There can be little doubt these men enjoyed their craft.

333

334

335

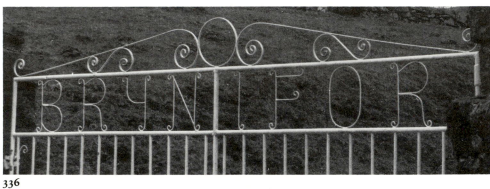

336

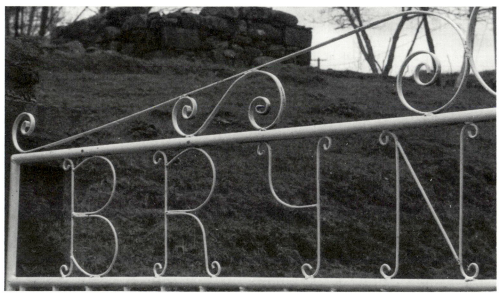

337

Modern examples of the same inclination are frequently found, although not always so original as (335) from Castletown-Bearhaven, Co. Cork, complete with punning T, or an iron gate from Bryncoedifor, Gwynedd (336, 337), where traditional iron scrolls consistently terminate the letters to give a simple and effective decorative pattern. The delicate forms have a good foil in the vertical bars below, and echo the scrolls above.

The most common early decorative letters were merely traditional forms with patterned infill. Two versions are used on the slate panel in (338) from Plungar, Leicestershire. In both, the basic letterform is the same, an english letter which, with its hairline thins and serifs, relates to lettering used by engravers. An example of 1761 from Thorne, Yorkshire (339) is more ingenious, with verticals split into two halves, plain and striped, and other strokes slit. The result, on what is basically an english letter with odd serifs, is successful, although it looks its age.

338

339

Woollen Manufacture

24th. of Septr. 1810, age

f ESTHER hi

the 21st. of June 1797, ag

heir Daughter. who died

AGED 17 YEARS.

VER their Son. of FORG

340

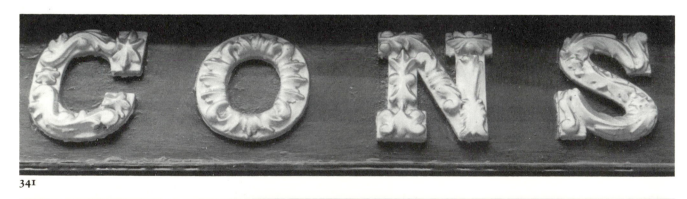

341

342

The stone at Great Crosthwaite, Cumbria (340) was erected in 1840, and the infilled decoration perhaps reflects type designs. Each letter is differently decorated. The overall form suffers, being a little less well-shaped than the undecorated lettering elsewhere on the stone.

More unexpected, every letter on the fascia at Ennis, Co. Clare (341, 342) is also differently decorated: so this is not the stock letter it first seems. It is altogether unique as far as I know, not only in the forms of decoration – rather like very good icing on a cake – but also in that the basic form is egyptian, and a good one at that (although the real surprise is that egyptians, with their solid forms and strong serifs – bold simple areas to fill – are not decorated more frequently). The decoration here is mainly foliage-derived, but the very odd first I seems to have a leg holding a (punning?) eye: almost the equivalent of bizarre illustrations on medieval manuscripts.

Some decorative effects derive directly from the tool used. The eye-dazzling sign at Corwen, Clwyd (343) has forms resulting from the way the brush was manipulated: not so difficult to do as it looks, once the basic movements are mastered. A rather sinister variant names a house in Dolgellau, Gwynedd (344).

A kind of formalisation of this effect is on the fascia at Buckingham (345). The structure is exactly the same, made more obvious by the two sides of the V-cut echoing the brush strokes. Unlike the brush-drawn examples, the O has central swellings in a successful attempt to reflect the other letters.

Although the gilded V-cut fascia lettering from Dublin (346) is actually formed differently, the effect, because of the boldness of the V-cut creating notched shadows, is unexpectedly similar to (345). The same pointed swellings on the round forms reflect the appearance of the other letters.

The cut-glass A and N from a pub window in Stamford Hill, London (347) are almost identical to the A and N in (346), and I suspect the other letters in both alphabets would be similar too. But the

way the light falls on these dissimilar materials makes their appearance very different. In any lettering, decorative or not, account must be taken of the material; the more complicated the form, the more likely is the material to exert its own influence.

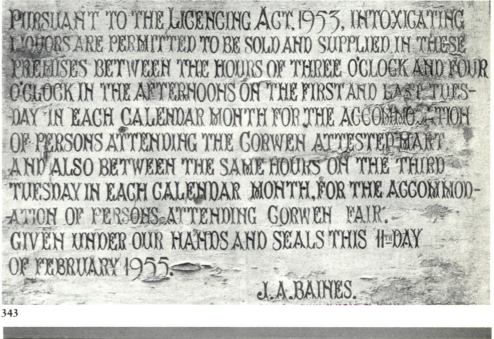

343

344

345

346

347

The decorative form of the previous letters largely grew out of the structure or the method of creating the structure. An alternative, non-structural, idiom, creating decorative elaboration mid-way in the strokes, is theoretically destructive of the natural form. An english letter of 1849 at Gosforth, Cumbria (348) swells to a point along the centre line, and a clarendon at Dalton-in-Furness, Cumbria (349) uses exactly the same device. In neither is one aware of any weakening of the letterform, and the word seems to be tied together by this firm central line. But the same device on a stone of 1839 from Wymondham, Leicestershire (350)

348

349

350

becomes confusing because the basic letterform itself is fatter and more distorted, with fish-tail serifs terminating thin strokes. The decorative swellings on the Ns, necessarily at an angle, interrupt the central line.

From a purist's point of view, the hollow blobs on the letters at Grantham, Lincolnshire (351) are even worse, being mere excrescences lacking even the V-cut to relate it to the form. The split terminations speak another language, and the A babbles away idiotically to itself. More coherent is the lettering at Settle, Yorkshire (352) where at least blobbed centres relate to blobbed serifs. Both these examples suffer from being pompously carved in stone; the more naive example at Sneem, Co. Kerry (353) can claim a folksy charm. But none of these three merit much time spent discussing them.

351

352

353

More examples of blobbing the middle illustrate a local tradition. Ulverston, Cumbria, again. A painted interior screen (354) could have been done forty or fifty years ago. The blobs there reappear in a fascia (355) of about 1981, although the letterform itself differs: serifs are more decorative, and the centre-line seen in (152) reappears to echo wittily the tongue-and-groove boarding. The blobs appear again in various guises on the Ulverston painter's masterpiece (356). Both of his basic letterforms are here, enriched by some of his optional extras. Penny plain, tuppence coloured. Not very good, is it? Yet the sight of this painted wall, about six feet high and conspicuously situated, is more pleasurable in the street than it might seem from the photograph. Better than a slick plastic sign. Ulverston is only a small market town in a secluded corner of England. The lettering looks at home there.

A final example of this widespread if unsatisfactory decorative device is on a cab door seen at Dingwall, Highland (357). Here, on this signed painting, the blobs are more restrained and form only an incidental part of the repertoire. Compared with the best Victorian work, this

354

355

356

example is – perhaps intentionally, certainly fittingly – vulgar. It suits a heavy lorry as railway lettering suits locomotives. But given the enthusiasm, and obvious pride, with which these cab doors are painted, who knows what developments may occur.

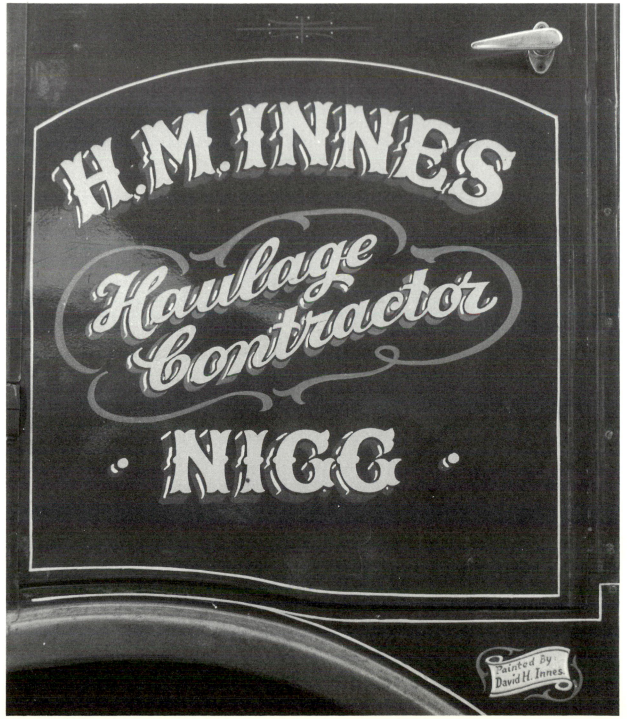

Quite different is the decorative lettering on a stone at Lanivet, Cornwall (358). The pattern is so much dependent upon three-dimensional cutting that it must be a carver's creation, despite its appearance in the land of type-book copiers. The ingenious effect depends upon a clever exploitation of the V-cut, but a lot of very odd things happen. These strange forms seem to be created by natural movements of the chisel, so that the pattern derives from the construction of the letters. Unlike much of the decorative lettering we have seen, which is a mess, these letters work.

Incidentally, the non-script form of r has been used in the word 'Parish'. Its successful handling here is almost certainly a result of the strong V-cut carver's form: a repetition in miniature of much of what is going on in the decorative letters.

A decorative nineteenth-century ceramic stock letter, with Ns upside down, is from Ulverston, Cumbria (359). The decoration consists merely of indecisive swellings and formless serifs. The attempt to suggest marble is ill-judged: these oddly formed letters look as if tarred and feathered. But they have a pleasing overall effect, enhanced by their placing on a single solid plank of wood.

Probably the most common nineteenth-

358

359

century stock letter, seen here at Bath (360), was of cast iron. Registered by Macfarlane's Saracen Foundry, Glasgow, in 1862, it was produced in several sizes. Sparely-employed foliage patterns enliven the letters with characteristically Victorian medieval overtones. A successful design, visually as well as commercially.

A letterform at Waterford (361), probably of wood, might also be a stock letter, though I have not seen it elsewhere. The well-designed forms are further enhanced by an unusual and effective section. Even the full stop is integrated into the design idiom.

Two letters with much in common are probably the brain-children of local signmakers, possibly even of the same person – for these men would frequently travel the country plying their trade. The Celbridge, Co. Kildare, example (362) is effectively a foliated and somewhat coarser version of (361) with less sophisticated letterforms but exploiting the same section. The lettering at Abbeyleix, Co. Laoise (363) has a section reminiscent of (360), and is again richly foliated. Both designs (of wood or, more likely, plaster) have been well worked out. Local signmakers are not above adapting existing designs, and these two examples may be personal variations on stock letters.

360

361

362

363

Two early and very different designs use foliage in some degree. The delicate incised letters at Whatton, Nottinghamshire (364) are created by scroll-like patterns which, although some way removed from realistic depiction of leaves, are by their organic nature suggestive of them. This shy and charming lettering is very different from some of the loud-mouthed 'Sacreds' and 'Erecteds' we have seen. It is also very different from the more forthrightly foliated date on Bright-

364

365

ling Church, Sussex (365). In general form these figures resemble certain typefaces of the period, but their appearance in this situation is unexpected.

The mention of decorative lettering usually brings nineteenth-century examples to mind, and here are three typical designs from characteristic situations. (366) and (367) are on a Soho, London, pub. The first is on a convex brass sill below the window: raised, vaguely medieval, its ungainly basic form has probably more fans than it deserves. The second, on the fascia, is V-cut, gilded and behind glass, and is of considerably better form. Basically simple bites out of the stroke terminations create – in combination with the V-cut, the gilding, and the outline painted on the glass – unexpectedly involved patterns. Yet more effective is the Keswick, Cumbria, fascia (368, 369) which I have been unsuccessfully stalking for years: either the blind is down, making photography impossible, or it is up and partly obscuring the letters, as here. These letters are not cut, merely painted and gilded under glass. Rich, robust, they are full of Victorian self-confidence. The foliage steps straight out of the stained glass of the period. These letters have the same bites and spikey serifs as (367), but are uncomplicated by any V-cut. The curved line across the letters is a reflection of that damn blind.

366

367

368

369

There can be little doubt that the vernacular lettering men are less successful at decoration than type designers. Even the nineteenth-century men seem to have been generally weaker, although much fine stuff must have disappeared. The sign behind glass at Porlock, Somerset (370), which appears to be gilded and painted (and possibly etched) is pleasing solely because of the decoration: the letterform itself lacks the vigour and grasp of form so apparent in the railway lettering.

A contemporary Irish example at Nenagh, Co. Tipperary (371) is an original idea with a wavy effect in the Es, Fs, and in a small way the serifs. The simple plebeian form is enhanced by a good use of shadows on the painted returns.

Two less adventurous designs are from Bridgnorth, Shropshire (372) and Birr, Co. Offaly (373). The former exploits the inner line used by the Ulverston painter in (152), but more forcefully and within an expanded letterform. The simple device is effective. The unevenly spaced Birr example uses a double stripe, and lozenge shapes along the centre-line: a successful interpretation of the typeface Fry's Orna-mented, originally designed in 1796. Such clean and humble decorative effects are within the capabilities of today's painters, and sympathetic to today's tastes. The two go together, I suppose.

A common means of achieving enrichment is to split the letter, decorating the upper half differently from the lower. A decadent example is seen in (374) from Birr, Co. Offaly. Far better are the two, obviously by the same man, one at Blessington, Co. Wicklow (375), the other at Dublin (376). For once, both the letterform and the decoration are equally well-handled: the only examples I have which begin to approach the quality once found in fairgrounds. The skills are still around, if we want to use them. The main difference between the two, apart from colour and tone, is that the cast shadow in (376) is not continuing the angle of the return, but is opposed to it: a more vigorous and satisfactory arrangement.

An attempt to create a personal style at Castletown-Bearhaven, Co. Cork (377) is one of several (of a similar nature but different form) by the same hand in the region. They are in bright boiled-sweet colours, sometimes with the colours changing from top to bottom of each letter, as here. This one has both Victorian and, faintly, art nouveau origins. The painter is aware of traditional devices such as the split serifs and central swellings of this example: nothing wrong in that, we are examining a tradition. But these devices, which look a little contrived at Castletown, have been used more naturally and more successfully by our Wexford friend in (378). This painter's wizard way with form, with its wilful abandonment of all known laws of perspective, seems unforced. His idiosyncratic decorative pattern develops from the construction of his letters; his sense of form, particularly three-dimensional form – perversely, in view of his perspective tricks – has an odd intensity and vehemence. And even in such a simple subject as lettering, to have a grasp of form is to have the key to your trade.

370

371

372

373

374

375

376

377

378

Epilogue

Some time ago I received a letter from the Kilkenny Design Workshops, Ireland, by the organiser of a signwriting project for the 1978 Kilkenny Arts Week – 'a marvellous week with ladders everywhere'. He enclosed a copy of one of the signwriters' autobiographies. Here it is.

Two hundred words of history of the life and times of one, James J. Stacey, otherwise Séamus Ó Stáisig

Once upon a time there was this boy, fresh faced eager and full of youth and joie de vivre. The year 1936 of our Lord. A couple of Intermediate Certificates with honours and a Leaving Certificate (single) with honours, plus a Matriculation Certificate sticking out of his pocket. The world at his feet. No wish of any kind in prospect, remember the year and the Economic War and wars and rumours of wars, real, that is.

Constantly aware of the disagreeable lurch of the heart, that comes with the realisation, that one is the persistent target for some anonymous hostility. Like the visible ineluctable approach of death, the emigrant ship seemed the only solution. University education was totally out of the question, being one of a family of twelve. The eldest, in fact, what began as an idyle was turning slowly into low comedy and looked like ending in tragedy.

My Father was a painter, decorator and sign writer, master of his trade and all aspects thereof. So it was to follow as the night, the day that I was also to take up the trade and allied arts. Thus it was in 1936 of our Lord I took the first steps, the first strong steps of hope. It was like the last beat of a heart, or the first fluttering steps of desire.

I remember working like a slave for the first year. My remuneration was the magnificent sum of half-a-crown per week – imagine half-a-crown!

There were compensations however, in the work I was doing and the comrades I had. There was Mike, Pat, Johnny, Jimmy and Danny (he was mad). They were all great journeymen and first class tradesmen to boot. I was indeed privileged to have worked beside them and learn my trade. They are all dead now. Alas!

The submerged seven eights of me, that more or less controls the most of every man's nature and actions, began to demand more satisfaction from my work. My Father did not work with the men – he being the 'Boss', as these men in his position were generally known sometimes affectionately, sometimes not.

In my third year of my apprenticeship my Father began to take me with him on his sign writing missions. He was the only sign writer on the job and he was a good one. There developed an innocent sexless liaison between us that achieved its own dynamics. Dynamics being the way to describe the situations that arose inevitably, when I became big headed and thought I knew it all, this, after a couple of years sign writing with my Father, God Bless him. He left me assignments where he knew I would create a situation, where I flirted with the idea of becoming a shambles and then utterly succumbing to it. Then I would hear it from him. He saved me many times from hypnotising myself to my own ultimate inundation in my own high-flying notions about sign writing.

I went through the mill all right with my Father. My perils were many, the struggle that threatened me on all sides was severe. The recompense since then has been glorious and the freedom of my choice is manifest. Without his adversity there would have been no conflict and without conflict there would have been no victory and with no victory there would have been no crown. The crowning glory came when I set out on my own. Forty two years of all sorts of sign writing, painting and decorating too. Forty two years of everywhere in Ireland, north to south and Dublin to Connemara. I worked everywhere.

I tried over the years to develop a style of my own. I created lots and lots of different styles. I remained with one for a period longer than the others i.e., extending the middle bars through the up-rights of letters. I abandoned this style a little while ago, but I find myself coming back to it each time I set out lettering.

The more sophisticated the terminology of communication becomes and the more it proliferates, the less is communicated. Let it not be said that the eloquence of the language could be surpassed only by the diversity of its intentions.

I digress. I began my trade career in 1936 of our Lord and I am forty two years now plying my trade. I have

lived successfully with my trade. I have no regrets. I try
not to suffer from frustration, it being basic, soul searing
and catastrophic. I try to press on regardless, per ardua
ad astra with all the intensity of unimpeded artistic nature.
Like Kipling, I try to fill each unforgiving minute with
sixty seconds worth of distance run. In the pursuit of
happiness, the almost always failure to achieve, lies, not
in the looking but looking in the wrong places. I would
like to think that I have found happiness and fulfilment in
my work. To re-iterate my earlier words – ars gratia artis.
Art itself could be an illusion, a joyful one but still an il-
lusion. Sometimes I feel, I hear and see a greater Michael-
angelo in the mere chirping of a sparrow. And so I would
look forward to the privilege of being of service to the
Kilkenny Arts Week as, perhaps, a culmination to my life
long endeavours in the field of sign writing. Then, I would
drink of life as other mortals drink of wine.

Let it not now be that the proud dreams of youth,
nurtured by young strength and unfettered hopes are
dissipated by the pitiless light of facts, as I gradually face
my own limitations and defects.

The privilege of working for the Kilkenny Arts Week
will obviate all doubts. I will have one moment in my life
when I can shout at the top of my voice that I am happy
with my existence.

RESPICE AD FINEM

Séamus Ó Stáisig

About a week after the event, Séamus Ó Stáisig died.

Probably the most fertile hunting ground for tombstones is the South Midlands – Nottinghamshire, Leicestershire and Lincolnshire. Most churchyards in this area have at least a few good stones, although probably nothing remarkably different from those I show. A particularly pleasant time can be had in the Vale of Belvoir. Devon and Cornwall are also unlikely to reveal many stones very different from my selection, apart from some shown in my previous book on tombstones. Lancashire, and especially Yorkshire, might be more rewarding: I have not covered the area as closely as I would wish. The scattered churchyards of Cumbria probably contain treasures I have missed. The area outside the Lake District might be fruitful, although slate is lacking here.

Scottish churchyards are not represented in this book; they could be explored to advantage (I have shown elsewhere some good examples from Moffat). As I mention in the text, I have been a little unlucky in Wales; more adventurous hunting would probably be worthwhile. And throughout the British Isles, good stones are awaiting the enthusiast, although many (both stones and enthusiasts) may be in a decaying state.

Shop fascias, street names, signs and notices with fine lettering, old or new, are to be come across anywhere; Ireland is an especially happy hunting ground for fascias. The rule is simply to keep one's eyes open, although it is advisable to forget about lettering while driving a car through a busy market town. Northern Scotland, Skye and the Outer Hebrides would seem to have little to show except on kipper boxes. I don't know about the Orkneys and the Shetlands. There must be much fine lettering in Glasgow and Edinburgh, but I've not found it. And despite a reviewer bitterly complaining that I showed no examples from the Wirral peninsula in my book on street names, I'm sorry to say that I have still not crossed the Mersey to investigate.

I have visited the main transport museums, but smaller collections are springing up regularly, together with private railways, and both will often have good examples of lettering on the exhibits. Cattle trucks and heavy transport lorries need to be looked at more thoroughly. Harbours and fishing ports nowadays probably contain little worthwhile. Canals (their engineering, boats, and architecture) should be investigated.

Unfortunately I have not covered a steam rally: many traction engines and suchlike have a lot of old, or old-style, lettering. As with the few pieces of traditional lettering remaining on fairground roundabouts, such examples need to be looked at with slight suspicion. They may have been repainted, and not quite accurately, so although still very decorative, they may be neither completely the genuine article, nor a new, original creation.

I have noticed, too late for inclusion in this book, several fine examples of the english form on portrait paintings, identifying the sitter. And labels in the Tate and National Galleries (on many Turners, for instance, presumably lettered about 1860) are often in this style.

My book is merely a paddle in muddy pools; a strong swimmer should be able to find clearer water, and sparkling treasure. It can be a very enjoyable pastime.

Acknowledgements

First, and most important, I must thank Lund Humphries, and especially John Taylor and Charlotte Burri. Their understanding of and enthusiasm for my aims is much appreciated.

Secondly, I must acknowledge my debt yet again to James Mosley's articles, especially his seminal one in *Motif 11* (Winter 1963–64). Without them, none of my books would exist. And without Nicolete Grey's book *Lettering on Buildings* (London, 1960), the subject would not exist.

John Trevitt, who acted as a kind of godfather to the project; Ron Costley (the Demon King?); and Colin Ridler, must all be mentioned. Their comments helped me clarify my text, and their criticisms clarified my aims.

Theo Olive enlightened me on the unexpected origins of the re-cut Bath street names.

I am particularly grateful to Gerald Tyler of the Kilkenny Design Workshop, Ireland, for sending me James Stacey's autobiography, and allowing me to use it.

Finally, I wish to thank the railway museums whose exhibits I illustrate, and particularly the National Railway Museum, York (part of the Science Museum, London), who own those exhibits, not only at York and London, but also at the GWR Museum, Swindon, and Darlington Railway Museum.

Index

Illustrated examples, listed by county.
The references are to *figure* numbers.